China's Southwestern
Silk Road

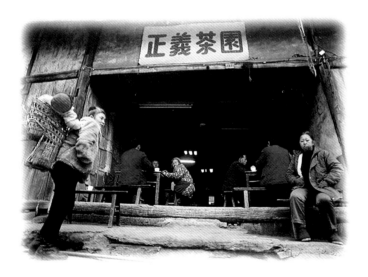

Ⓦ Foreign Languages Press Beijing

"Culture of China" Editorial Board:

Consultants: Cai Mingzhao, Zhao Changqian, Huang Youyi and Liu Zhibin
Chief Editor: Xiao Xiaoming
Board Members: Xiao Xiaoming, Li Zhenguo, Tian Hui, Hu Baomin, Fang Yongming,
Hu Kaimin, Cui Lili and Lan Peijin

Written by: Lu Zhongmin
Photographer: Lu Zhongmin

Chinese Text Editor: Wang Zhi
Translated by: Yu Ling, Gu Wentong and Chen Ping
Designed by: Wang Zhi

First Edition 2002

China's Southwestern Silk Road

ISBN 7-119-03052-3

© Foreign Languages Press
Published by Foreign Languages Press
24 Baiwanzhuang Road, Beijing 100037, China
Home Page: http://www.flp.com.cn
E-mail Addresses: info@flp.com.cn
 sales@flp.com.cn
Distributed by China International Book Trading Corporation
35 Chegongzhuang Xilu, Beijing 100044, China
P.O.Box 399, Beijing, China

Printed in the People's Republic of China

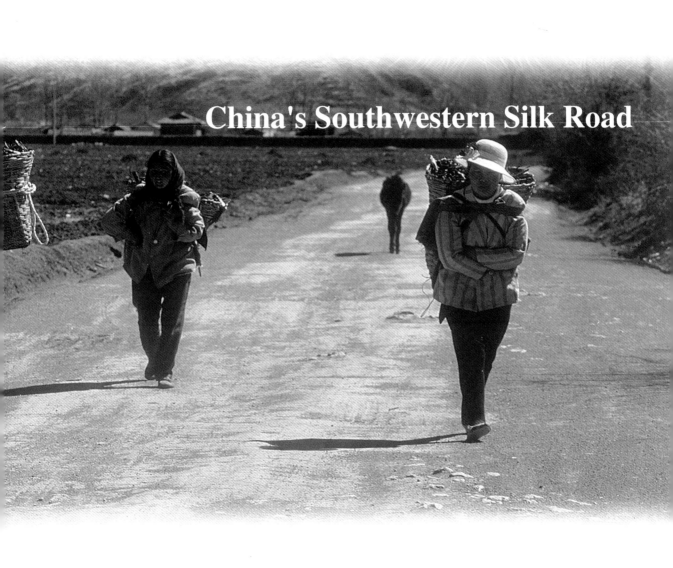

China's Southwestern Silk Road

The Route of China's Southwestern Silk Road

The Southwestern Silk Road was called the Shu (Sichuan)- Shendu (India) Road in ancient times. Starting from Chengdu and ending in India, it consisted of the Lingguan Road, Wuchi Road and Yongchang Road.

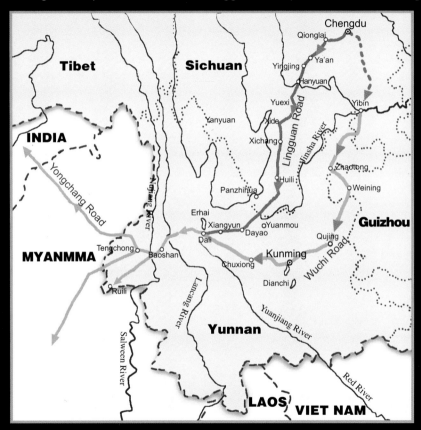

■ Lingguan Road: Chengdu (anciently named Shudu, same below), Qionglai (Linqiong), Ya'an (Qingyi), Yingjing (Yandao), Hanyuan(Zhaidu), Xichang (Qiongdu), Dayao (Qingling) in Yunnan Province, Dali (Yeyu)

■ Wuchi Road: Chengdu, Yibin (Bodao), Zhaotong (Zhuti), Weining in Guizhou Province (in the State of Yelang in ancient times), Qujing (Weixian), Kunming (Dianchi), Chuxiong, Dali

■ Yongchang Road: Dali, Yongping (Bonan), Baoshan (Yongchang), Tengchong (Tengyue), Myanmar, India

Contents

Preface

Over 2,000 years ago, China began to conduct transactions with other civilized countries through trade in commodities such as silk, colored glaze, gold, pottery and gems. As silk was the major and the most typical commodity for export, the thoroughfare linking China with the Western world for cultural and economic communication was referred to by contemporary scholars as the "Silk Road."

The Northern Silk Road, which was opened in the 2nd century BC, started at the ancient capital of the Han Dynasty, which is now known as Xi'an, and traversed westward through the loess plateau in present-day Shaanxi and Gansu provinces, to enter the Hexi (Gansu) Corridor and the Taklimakan áin the present-day Xinjiang Uygur Autonomous Region. The road then crossed the Pamirs, and went through Central and Western Asia to reach the eastern shore of the Mediterranean Sea.

The opening of the Southwestern Silk Road was earlier than that of the Northern Silk Road. As early as before the 4th century BC, there were trade caravans on the rugged roads in southwest of China . In 122 BC when the great explorer Zhang Qian of the Han Dynasty returned to Chang'an (Xi'an) after his mission to the western regions, he immediately reported to Emperor Wudi that he had seen in Daxia (present-day northern Afghanistan) cloth and bamboo goods from Sichuan. He found out that these items had been transported from India, so he realized that Sichuan had long since been connected to India by road. Compared with the northwestern route to the kingdoms of the western regions, this was shorter and safer, and would be a more convenient route from China to India. For the next 2,000 years, the official post road of each dynasty and in modern times highways and railways followed this route.

The Southwestern Silk Road and the Bashu Civilization

Present-day Sichuan Province was occupied by the ancient states of Ba and Shu, and so it is also called

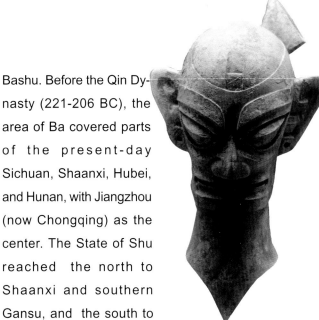

Human faces in bronze, unearthed from Sanxingdui in Guanghan City, Sichuan, showing exaggerated sculpting art.

Figure of an acrobat, Han Dynasty

Bashu. Before the Qin Dynasty (221-206 BC), the area of Ba covered parts of the present-day Sichuan, Shaanxi, Hubei, and Hunan, with Jiangzhou (now Chongqing) as the center. The State of Shu reached the north to Shaanxi and southern Gansu, and the south to Yunnan and northern Guizhou, with its center on the Chengdu Plain.

In July and August of 1986, two ancient sacrificial pits were respectively discovered at Sanxingdui in Sichuan, in which were found over 1,000 gold and bronze wares and other precious historical relics, indicating great achievement made during the period from 2700 to 900 BC. Scholars believe that Sichuan is a separate source of Chinese civilization.

In ancient times, Sichuan was regarded as a land of abundance, blessed with a favorable climate, fertile land, rich resources and people of outstanding talent. As early as 2,500 years ago, Li Bing and his son constructed the Dujiang Weir, the oldest and most famous irrigation network in China. It is still in use to this day. The development of water conservancy enabled Sichuan to become the most prosperous

region in China early in the Han Dynasty (206 BC-220 AD). The State of Qin became more powerful partly because of its development in Sichuan, which enabled it to conquer the other six states and unified the whole of China. In the following Three Kingdoms Period, the State of Shu led by Liu Bei, the weakest among the three, was

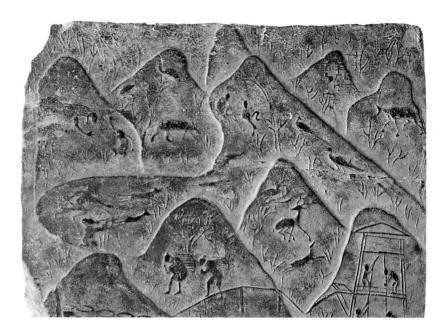

Illustrations of Well Salt Production, unearthed in Pixian County, Sichuan, Han Dynasty.

able to fend off the states of Wu and Wei for decades as it was based in the Sichuan area.

Sichuan is the birthplace of silk, and Sichuan brocade became well known as early as in the Han Dynasty. This is also the place where tea was first planted and appreciated in China. Sichuan was also the center for well salt production and one of the leading metallurgical centers in China. Moreover, it was the first place in the world where people utilized natural gas. Culturally, it was the birthplace of Taoism, and has the greatest number of large statues of Buddha compared with other provinces and produced the great men of letters Yang Xiong and Sima Xiangru in

the the Han Dynasty. The poets Li Bai and Du Fu found much inspiration in the scenery of Sichuan.

The well-developed culture, commerce, and science and technology in the Bashu area made it a natural part of the commercial highway known as the Silk Road.

Rough Tracks Become a Busy Highway

The center of the Bashu civilization was in the Sichuan Basin, which covers over 200,000 sq km. The

bottom of the basin is 300~600 m above sea level, surrounded in all directions by lofty mountains of 1,000~3,000 m above sea level. There is not one flat road stretching out of the basin. A famous line in a poem by Li Bai goes: "It is as difficult to negotiate the dangerously high and steep paths of Sichuan as it is to climb up to the sky." But the mountains couldn't block the way to the outside world. According to archeological findings, as early as in the Shang Dynasty (1600-1100 BC), the people of Bashu made contact with the people of the Central Plain. In the Western Han Dynasty, a plank road, known as the Golden Ox Road, was constructed along cliffs to reach the other centers of Chinese civilization.

The major communication routes to and from the Bashu Basin are as follows: To the east, the Yangtze River, the biggest in China, affords navigation to the sea. The present-day Sichuan-Shaanxi highway and the Baoji-Chengdu railway follow the route of the ancient Golden Ox Road. To the west, a road has connected Bashu with Tibet built since the Tang Dynasty, now called the Sichuan-Tibet Highway. To the south, there were two routes: One was the Wuchi Road

The kings of Shu, Wangdi Duyu and Congdi Bieling. Their tombs are in the Wangcong Ancestral Temple in Pixian County.

(named so because the road was five-chi or some 166 cm wide) from Yibin to Yunnan; the other was the Lingguan Road from Xichang to Yunnan, two trunk lines of the Southwestern Silk Road.

The Southwestern Silk Road went through the Sichuan Basin, across the Yunnan-Guizhou Plateau, the Jinsha, Jialing and Lancang rivers, the Qionglai Mountains and the grand canyon of the Hengduan Range... All these places have had a mysterious appeal for centuries, being known variously as "land of abundance,"and as a region where a multitude of exotic ethnic groups live.

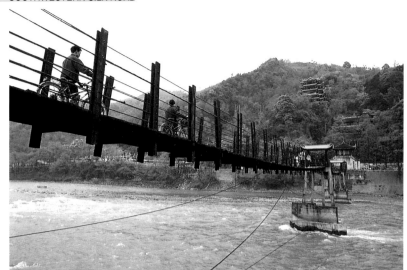

The Anlan Bridge at the Dujiang Weir has a length of 500 m, making it the longest ancient chain bridge extant in China.

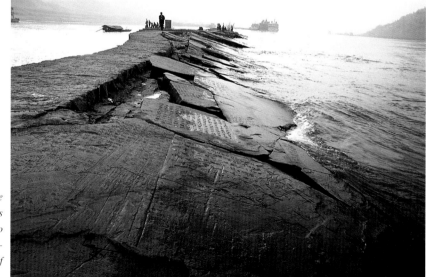

Baiheliang at Fuling is a curiosity of the Yangtze River. Every year, when the Yangtze water rises it is submerged. When the water ebbs it is two meters above the water. There are 174 inscriptions on it written by celebrities in the course of the 1,200 years since the Tang Dynasty.

Chengdu, the Starting Point of the Southwestern Silk Road

Chengdu, the Starting Point of the Southwestern Silk Road

Prosperous as the starting point of the Southwestern Silk Road in the past, Chengdu is now a modern metropolis and the capital city of Sichuan Province. It covers almost the whole of the Chengdu Plain, with an area of 12,456 sq km and a population of 9.6 million. Due to its central position in southwestern transportation, Chengdu has easy access to other parts of the country by water, land and air. The intimidating rough, hard roads of Sichuan became history long ago.

About 2,300 years ago, the ninth king of ancient Shu moved his capital from Pixian County to where Chengdu now stands, and named it Chengdu (meaning "become the capital"). In 316 BC, after General Zhang Yi of the State of Qin conquered Bashu, tens of thousands of people from Qin were moved to the Sichuan area. City walls and a moat were added to Chengdu, imitating Xianyang, the capital of Qin. With the unification of China by the Qin Shi Huang (First Emperor of the Qin), Chengdu was put under the control of Shu Prefecture. After the Han Dynasty, several small states were established in the Chengdu area, one after the other, the most famous one being the State of Shu in the Three Kingdoms Period. In recent years, the sites of five ancient cities dating back 5,000 years have been discovered in counties of Pixian and Xindu, and near the Dujiang Weir, not far from Chengdu. They shed new light on the history of Sichuan. As a famous historical and cultural city, Chengdu has many ancient streets and lanes. There are also many cultural relics in and outside the old city proper, such as Zhuge Liang's Memorial Hall, Du Fu's Memorial Hall, Wang Jian's Tomb and the Qingyang Palace, each giving testimony to the city's glorious past.

Sericulture was first developed in this area. In fact, the name Shu itself means "wild silkworm." The state is said to have been founded by Can (meaning "silkworm") Cong and Yu Fu over 4,000 years ago. This is mentioned in the poem The Sichuan Road by Li Bai: "Long ago Can Cong and Yu Fu founded the Kingdom of Shu." Leizu, the wife of the Yellow Emperor and purportedly the inventor of silkworm raising, was said to be a native of Sichuan. There were once many temples to the Cocoon God in Sichuan, with special rites for worshipping the Horse-head Goddess — a deity with

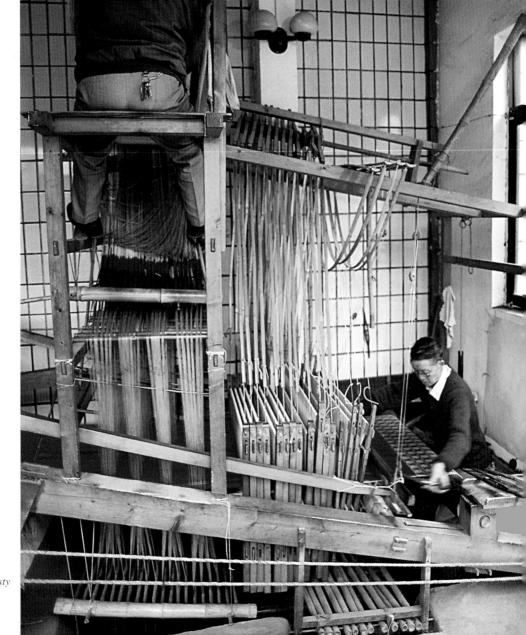

Demonstrating the Qing Dynasty hualou loom.

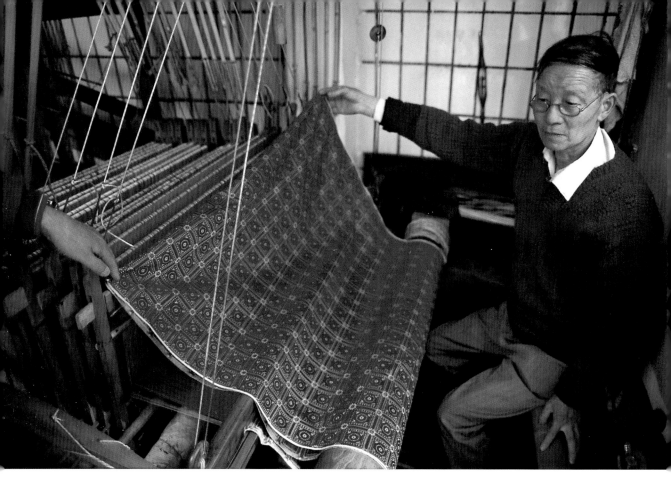

Exquisite silk woven using the hualou loom.

Sichuan embroidery is one the four famous embroidery schools in China.

a horse's head but a human body. Legend has it that a girl whose father had been captured by invading tribesmen vowed that she would marry whoever rescued her father. A white horse carried her father back,

but the man would not marry his daughter to a horse. He killed the horse, flayed it, and hung the skin up to dry. Suddenly, the hide wrapped the girl up in itself, and flew away. The horse's hide turned into a cocoon, and the girl turned into a silkworm.

Textile workshops appeared at an early date in Sichuan. The Jinjiang River flowing past Chengdu acquired its name (*jin* means "brocade") because the weavers often washed their brocade in it. In the Han Dynasty a special administrative organ known as the Jinguan was set up in Chengdu to supervise the brocade weaving business. So Chengdu was also called Jinguan City. The brocade and cloth made in Sichuan soon became famous far and wide. The cloth that Zhang Qian saw in Daxia was silk and hemp fabric made in Sichuan. The brocade of Sichuan is somewhat thick, with a smooth and lustrous surface. A Han Dynasty observer noted, "Sichuan brocade is as highly priced as gold because it is so difficult to make. Hence, the character meaning 'brocade' is written by com-

The people of Chengdu are well known for their love of tea. The most common sight in the street is teahouse, and the most lively place at weekends in a park is also a teahouse.

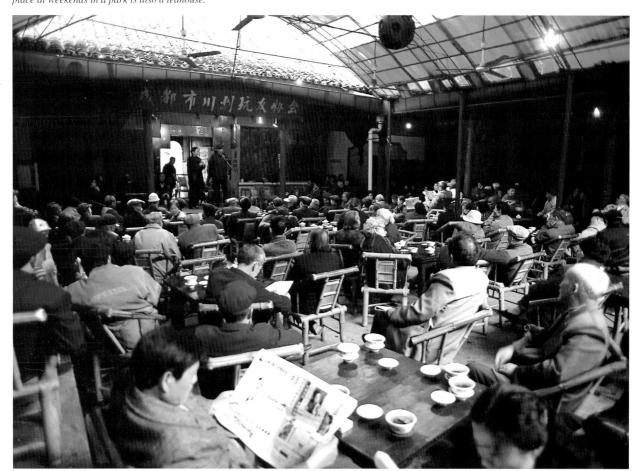

bining the two characters gold and silk." During the Three Kingdoms Period, silk was the major source of revenue for the Kingdom of Shu. During the Tang Dynasty, 100 bolts of silk and brocade were presented to the emperor as tribute from Chengdu every year. Sichuan silk was not only sold to Europe and other parts of Asia through the southern and northern Silk Roads, but also shipped across the sea to Japan, where it was called "Shujiang brocade."

The Sichuan Brocade Factory in Chengdu preserves a *hualou* loom dating from the Qing Dynasty, which was developed from the *juzhi* and *xiezhi* looms of the Eastern Han Dynasty. Two veteran weavers showed us how the machine was operated. They worked in perfect coordination, one controlling the top part and the other, the bottom, using both their hands and their feet to pull the thread and cast the shuttles. Older weavers told us that this kind of loom was used up until the 1950s.

The platform where Sima Xiangru played the zither, in the Wenjun Garden.

17

*The ancient lanes of Qionglai remind
people of its days of prosperity.*

Qionglai, the First Prefecture in Southern Sichuan

Qionglai, or Linqiong as it was called in ancient times, is located 75 km southwest of Chengdu. Referred to as the "first prefecture in southern Sichuan," it was a vital passage on the ancient Silk Road. In 311 BC, right after Shu was annexed by Qin, local magistrate Zhang Ruo started to build four big cities—Chengdu, Pixian, Linqing and Jiangzhou (present-day Chongqing City). Qionglai is now named Qiongzhou, a city with a population of 600,000 people.

In a narrow lane in this ancient city, there is the Wenjun Garden, which is connected with the beautiful love story of Zhuo Wenjun and Sima Xiangru. Sima Xiangru (179-117 BC) was a native of Chengdu and an outstanding man of letters of the Western Han Dynasty. In the reign of Emperor Wudi, he made great contributions to the opening up of the Silk Road in the Sichuan region. Falling in love with beautiful Zhuo Wenjun, he won her by playing the sweet and melodious tune *Phoenix Seeking His Mate* on the *qin* (a type

of zither). Her father, however, opposed the match, and so the two lovers eloped. Returning to Linqiong, they opened a small wine shop where the Wenjun Garden stands today. The Wenjun Well in the garden is said to be where they got water to make wine. The story goes that Wenjun nursed a sick old man clad in rags and shivering in the cold wind. When he left, he told Wenjun, "Isn't the well in your back yard full of mellow wine?" Sure enough, the fragrant smell of mellow wine came from the well that night.

In Taohua Village, along this ancient road, was discovered an ancient stone pipeline for transporting natural gas. In the 1960s, a Qing Dynasty stele was found near the Tiangang Temple, on which was inscribed "The site of a Tang Dynasty fire well." In the Sui Dynasty (581-618), Huojing (Fire Well) County was set up here. The first county magistrate was Yuan Tiangang, for whom the Tiangang Temple was built. Qionglai was the first place where the natural gas (or "fire well") was used in the world. As early as in the

Thousands of ancient articles were unearthed in Qionglai from the kilns at Shifangtang and residential houses built in the Tang Dynasty.

Western Han Dynasty, the locals had connected thick bamboo tubes to the "fire well" and lit the gas which came out of the tube to boil salt. In recent years, six sources of oil and natural gas have been found in the Qionglai area, and gas has been put to industrial and residential use.

As early as in the Qin Dynasty, Linqiong was well known for its production of salt, iron and silk. Iron farm tools made here were transported through the South-western Silk Road to Yunnan, Guizhou, the Red River delta in Vietnam and the northeastern part of Thailand. There are many cultural relics that the Qionglai people are proud of, such as the Tang Dynasty kilns at Shifangtang, ruins of residential houses, Mount Shisun (Stalagmite), bas-reliefs on cliffs in the Huazhi Temple, the Huilan Tower. Today, the local bazaars are also fascinating for visitors.

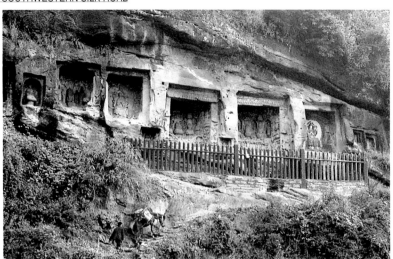

Statues engraved on cliff faces on Mount Shisun on the Silk Road in Datonggou Gorge, 30 km northwest of Linqiong. There are 739 statues of Buddha in 33 niches, mostly carved in the middle or late Tang Dynasty.

Dabei Yard in Huojing (Fire Well) Town, Qionglai. It is said that there is the mouth of a fire well in this yard.

At a country fair folk doctors treat patients with traditional Chinese medicine.

Ya'an, Ancient Golden Pivot of Eastward Journey

Ya'an, Ancient Golden Pivot of Eastward Journey

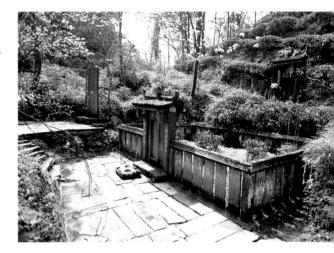

Going southwest from Qionglai, the Silk Road reaches Ya'an – a region comprised of the city of Ya'an and seven counties, and covering 15,062 sq km. Ya'an is a mostly mountainous region between the Sichuan Basin and the Qinghai-Tibet Plateau, with the western part at a higher altitude than the eastern part. The ancient route used to go from Huojing Town in Qionglai, across Mount Zhenxi and the Qinglong Pass to Lushan County, along the Qingyi River and over the Feixian Pass, to Tianquan and Yingjing, finally reaching Hanyuan after crossing the Daxiangling Mountains. After the Song Dynasty, the main trunk was moved to the Mingshan-Ya'an route, reaching Hanyuan by way of Yingjing.

The Best Tea in Sichuan

Mount Mengshan, the most famous tea-producing area in Sichuan, in Mingshan County, is 1,440 m above sea level, with gentle and graceful slopes and abundant precipitation of 2,000-2,200 mm a year. In the Western Han Dynasty, a man named Wu Lizhen planted seven tea bushes on top of Mount Mengshan. In the *County Annals of Mingshan*, it is recorded that

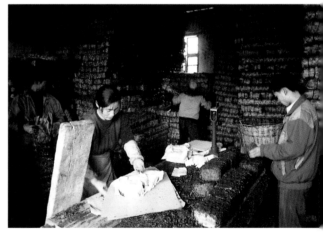

The brick tea processed in this small factory is transported to Tibetan pasture areas.

The Qingfeng Royal Tea Garden on Mount Mengshan in Mingshan County was the first place where tea was planted in China.

Ya'an in the rain

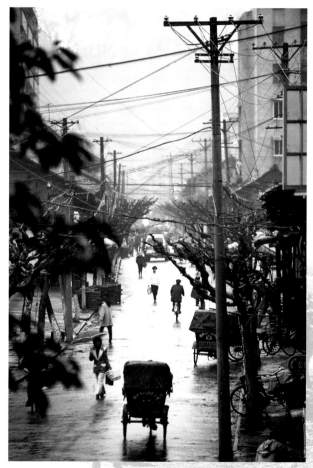

"Mengshan tea has long, thin and tender leaves, colored yellowish green, and with a sweet and pure taste." Said to be good for the health and to promote longevity, the tea was also called "immortal tea" and listed among articles of tribute from Sichuan to the imperial court. It even said that "the tea on top of Mount Mengshan is as well known as the water in the Yangtze River." Huangchayuan, or Royal Tea Garden, where Wu Lizhen planted the "immortal tea" and a hall in his memory are located on top of Mount Mengshan. According to an ancient record, tea began to be produced in Sichuan only after the area fell under the rule of the Qin Dynasty. Over 150 counties in Sichuan produce tea, but Mingshan tea is the most famous. As Mingshan was an important station on the ancient Silk Road, tea naturally became a major commodity for trade.

The Rainy City of Ya'an and Age—Old Shangli Town

At the center of Ya'an City, there is a statue of the

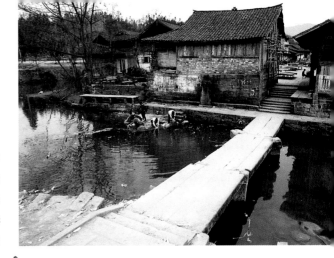

goddess Nü Wa patching up the sky. As Ya'an has an annual precipitation of 1,774.3 mm, 74% of which falls at night, it is called "the rainy city where water leaks through a hole in the sky." Occupying a key strategic position at the western edge of the Sichuan Basin, in ancient times Ya'an belonged to the State of Qingyiqiang, and became part of Yandao County in the Qin and Han dynasties. It was known at that time as a "golden pivot for eastward transportation on the Lingguan Road." In the Northern Song Dynasty, a market mainly for tea and horses was set up here, making it a commodity exchange and distribution center among the people of various ethnic groups in western Sichuan.

Along the ancient Silk Road from Ya'an to Linqiong in the north, there are numerous

The ancient town of Shangli is located in a beautiful setting.

Shuangjie Memorial Arch in Shanggu Town, Ya'an City was built in 1839 in honor of the daughter and daughter-in-law of a family named Han who remained chaste after the deaths of their husbands, respectively. Standing 11.25 m high, the arch shows depictions of 20 stories from traditional dramas, with more than 100 different figures.

scenic spots and historical sites. They include White Horse Spring, Shangli Town, Shuangjie Memorial Arch (for Two Chaste Women), Han Family Courtyard, Yellow Dragon Lake and Bifeng Valley, all located in an area of 30 sq km. Shangli Town is famous for its traditional cottages. Shangli used to be a busy pass on the Southwestern Silk Road, called Luochang in ancient times, but modern highways have left it a quaint backwater. However, its well-preserved ancient residential houses and the unique local custom have made it a hot place for tourism.

The Han Dynasty Pillars and Painted Bricks of Lushan

Lushan was called Qingyi County in the Qin and Han dynasties, and is well known for its Han Dynasty relics. In its Museum of Stone Carvings there are over 20 art works on stone, representing the grandeur and vigor of Han Dynasty art. In addition, Lushan is home to pillars also dating from the Han Dynasty. Erected in front of or on either sides of ancient palaces, city gates and mausoleums, these pillars indicated social status and rank. Among the 25 Han Dynasty monumental pillars extant, 16 are in Sichuan. Gao Yi's Monumental Pillar in Ya'an was built in AD 209 (in the 14th year of the Jian'an reign period) of the Eastern Han Dynasty. It is the best-preserved of all the ancient pillars in Sichuan. The design "Nine Sons of the Dragon" shown in relief under the eaves of Fan Min's Pillars in Lushan is a record of the origin of the State of Ailao. According to the stele, Fan Min was once prefect of Yongchang.

On the stone coffin of Wang Hui are carved images of buildings, a money tree, dragon, tiger, tortoise and phoenix. Han Dynasty bricks unearthed in Baoxing County have geometrical designs, inscriptions, and portrayals of social and productive activities ranging from sacrificial rites and hunting to harvesting, iron-smelting, salt production, wood cutting, rice husking and folk performances.

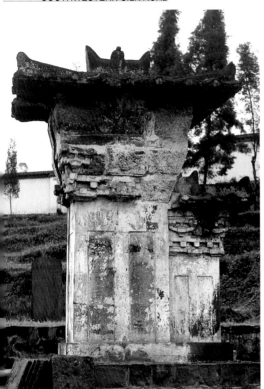

Fan Min's Pillar in Lushan was built in AD 205, the 10th year of the Jian'an reign period of the Han Dynasty.

Stone animals in the Lushan Museum of Stone Carvings

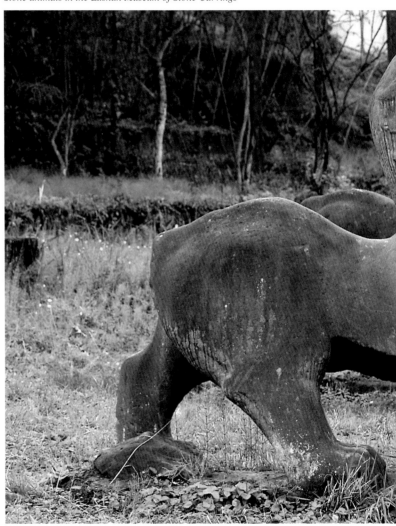

The stone coffin of Wang Hui of the Han Dynasty

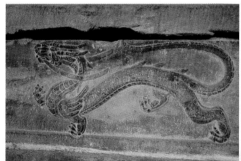

A flying dragon carved on Wang Hui's stone coffin

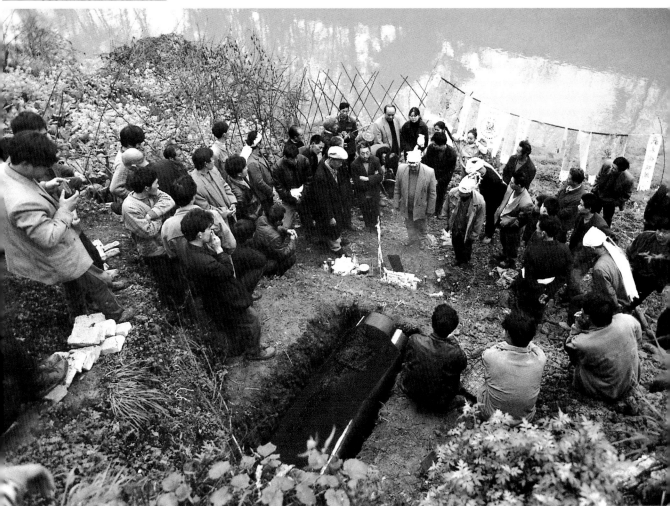

A funeral in Lushan.

An ancient weapon of the State of Shu unearthed in Baoxing

Bricks with carvings of the Han Dynasty unearthed in Baoxing

Home of the Giant Panda and Tibetan Village

Going north from Lushan on the highway along the Qingyi River you will reach Baoxing. In 1869, a French missionary, Père David, came to Fengtong Village in Baoxing, where he discovered and named the giant panda. His exhibition of a giant panda in Paris caused a worldwide sensation. Since the 1950s, 113 giant pandas have been presented to the state, of which 14 were chosen as state gifts to other countries and became friendship envoys of the Chinese people.

To the north of Fengyong Village there is Qiaoqi (or Yaoji) Village which in the Tibetan language means "beautiful mountains and rivers." Here the Tibetans are dressed somewhat like the Yi people. Their houses are built against the mountain, looking similar to castles. They are called *guozhuang*, and are square and normally have four stories. The bottom story is for livestock. The second story, about 40-50 sq m, contains a niche with a statue of Buddha and serves as a living room. Warm and hospitable, the Tibetans like to gather together

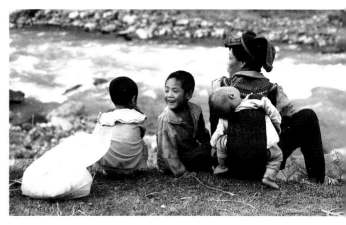

The costume of the Tibetans of Qiaoqi is similar to that of the Yi people.

with relatives or fellow villagers to celebrate a harvest, a new house, a marriage, etc. They sometimes dance around their fireplace the whole night. On the third floor are bedrooms, and on the fourth is the grain warehouse, called "cabinet of fortune." To the north of the village lies snow-capped Mount Jiajin, which the Chinese Red Army crossed in their 25,000 *li* Long March (1934–1935).

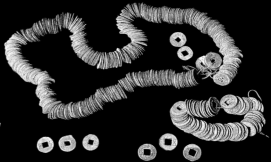

Antique coins found in Yingjing

Yingjing, Ancient City of Yandao and Hanyuan, "Yak City"

The ancient city of Yingjing on the Silk Road was re-named Yandao after Shu was conquered by Qin, and the old city site is still visible today. Han Dynasty Emperor Wudi bestowed a hill rich in copper on his favorite minister Deng Tong, and ordered him to set up a mint and produce a unified coinage. During the Warring States Period and the Qin and Han dynasties, Yandao was a place of strategic importance. It was also a trading center and a base for producing and exporting copper and iron, together with silk, to exchange for cattle and horses. From the Tang to the Qing dynasties, Yingjing was a major market for trading tea and horses between the Han and Tibetan peoples.

Gucheng Village in Liuhe Township, on the site of ancient Yandao City, is famous for producing Yingjing earthenware pots. Every family here has a small workshop where the whole production process is carried out, from molding and shaping to firing. Their wares are placed for sale alongside the main road. It is said

that Yingjing earthenwares, made of clay and coal ash, have a history of over 2,000 years.

Not far south of Yingjing there is a very high and steep mountain ridge – the Daxiangling Mountains – stretching 250 km and forming the southwestern barrier of the Sichuan Plain. Over 40 peaks there are more than 3,000 m high. Passing the Daxiangling Range, the Lingguan Road reaches Hanyuan, which was part of the State of Zuedu in ancient times. In AD 135, during the Han Dynasty, Maoniu County was set up here and garrisoned as a strategic location. Located on the slopes of the Daxiangling Mountains was ancient Qingxi City, facing deep ravines in three directions. Remnants of the old city walls, city gate and a citadel outside the city gate can still be traced. Around the city walls there are old houses and streets, as well as a grand Confucian temple. Qingxi is noted for its Chinese prickly ash, which is regarded as a good seasoning spice for Sichuan cuisine. It was delivered to the imperial court as tribute from the Tang to the Qing dynasties.

Mount Erlang and Luding Bridge

The Sichuan-Tibet highway, stretching from Ya'an to Lhasa, capital of the Tibet Autonomous Region, is over 3,000 km long. It was built following an ancient Tibetan road, and for centuries was the only route from the Central Plain via Sichuan to Tibet. The first high mountain, Mount Erlang, to be crossed when traveling westward from Ya'an to Kangding and Tibet, is 3,040 m above sea level. In the 1950s the Chinese People's Liberation Army built a winding mountain road across Mount Erlang in extremely adverse circumstances for the peaceful liberation of Tibet. Now a tunnel over 4,000 m long through the mountain is open to traffic.

Luding Bridge and the Luding County town

Leaving behind the lush green mountain and the unbroken drizzle on the eastern side of Mount Erlang, the landscape becomes vast and open, stretching into the remote distance. Soon, we reach the Luding County town. On the surging Dadu River stands Luding Bridge, which was completed in 1706 during the reign of Qing Dynasty's Emperor Kangxi. The name Luding was actually given by the Emperor. This iron chain bridge is one of many found on the South-western Silk Road. Such bridge originated from a bridge built with thin bamboo strips. With a total length of 101.67 m, the bridge has 13 iron chains, each weighing 2.5 tons, hanging 14.5 m above the water. In the 1930s, when the Chinese Peasants' and Workers' Red Army came here on its Long March, it found that its Guomintang opponents had burned the planks on the bridge, leaving only the chains. Braving heavy gunfire, 22 Red Army heroes scrambled across the chains, and assured victory.

Pagodas in the Tagong Temple

Kangding

The 150,000 sq km of land west of Mount Erlang belongs to the Tibetan Autonomous Prefecture of Garze, which consists of 18 counties and has a population of 820,000. The prefecture, at an elevation of 3,500 m, has a beautiful landscape. Some 40 km west of Luding is Kangding, capital of the prefecture, which is widely known for the *Love Song of Kangding*. Because of this song, Kangding is better known than Garze. The ancient name of Kangding was Dajianlu. Legend has it that a chieftain of a troublesome local tribe was caught three times by Shu's master strategist Zhuge Liang and each time he was reliesed. To show his gratitude, the tribe leader agreed to retreat for a distance of a throw of an arrow. The arrow shot by Zhuge Liang landed in Dajianlu, which was several hundred kilometers to the west. So the tribe had to move to the west of Dajianlu. In the Song Dynasty, a horse and tea market operated here, and from the Ming Dynasty on, it was a regular stopping place for envoys from Tibet carrying tribute to the capital. So the Southern Silk Road linking Garze, Tibet and India was thus formed. In 1939, Kangding was made the capital of Xikang Province, exercising jurisdiction over Changdu, Xichang and Ya'an.

A Tibetan family

A town on the Southwestern Silk Road, bustling and prosperous in ancient times, is now tranquil.

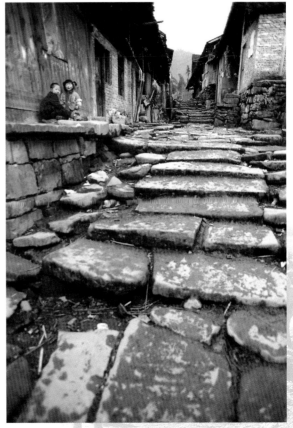

A hitching post in front of an ancient dak is a reminder of past prosperity.

The entrance to a stockaded village.

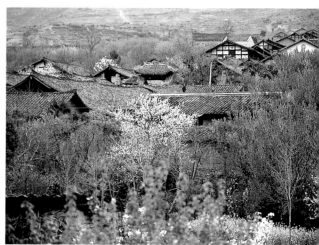

Many traditional houses are still to be found in the small towns on the ancient Southwestern Silk Road.

Yingjing is still famous for its earthenware.

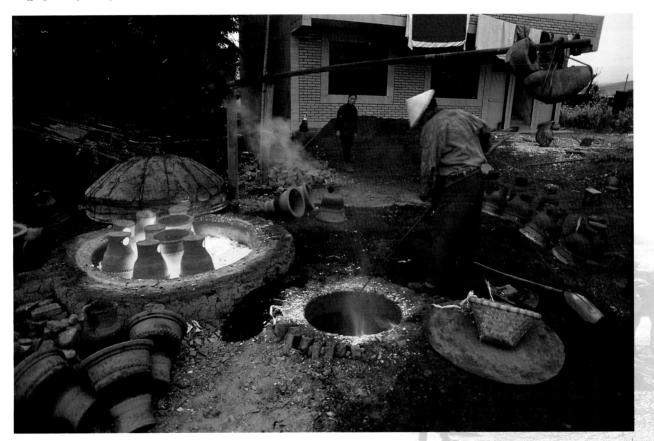

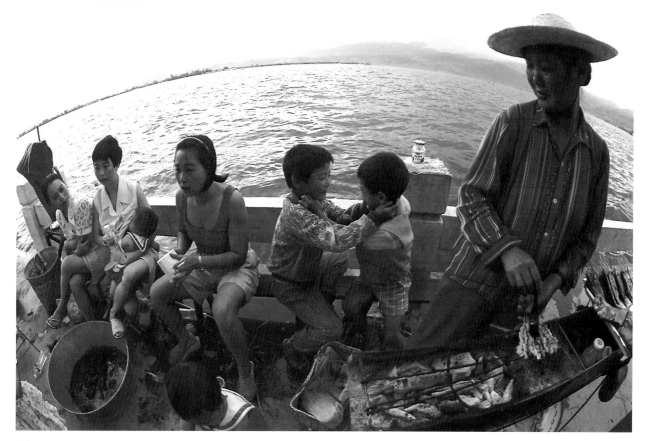

Qihai in summer

Entering the Big Liangshan Mountains

Entering the Big Liangshan Mountains

The ancient Lingguan Road goes southward from Ya'an, through deep ravines and valleys, and reaches Ganluo County in the present-day Yi Autonomous Prefecture of Liangshan. There are 16 counties and one city under its administration, including Xichang, Zhaojue, Butuo, Xide and Yanyuan, half of which are on the main route of the Southwestern Silk Road. The total area of the prefecture is 60,115 sq km, and is inhabited mainly by a million Yi people, the biggest Yi community in China. In 130 B.C. Emperor Wudi sent Sima Xiangru to the southwest to open the Lingguan Road and build a bridge over the Sunshui River so that the Silk Road could reach Qionglai. This laid the basis for the ancient administrative divisions in the Liangshan area.

Ganluo, a Deep Gorge on the Ancient Silk Road

Ganluo lies in a deep and serene valley, once the northern gateway to Liangshan Prefecture. The ancient route cutting through the rocky mountains is still well preserved, and grooves in the roadbed made by

The ancient Silk Road runs through a deep valley.

countless horses over the centuries can still be seen. A trade caravan traversing this route normally had 20 to 30 horses or mules, although caravans with as many as 300 have been known. Each such caravan had its own head, rules and disciplines.

On the Dingshan Bridge in the south of Yuexi Town, the imprints of innumerable horses' hooves can be seen.

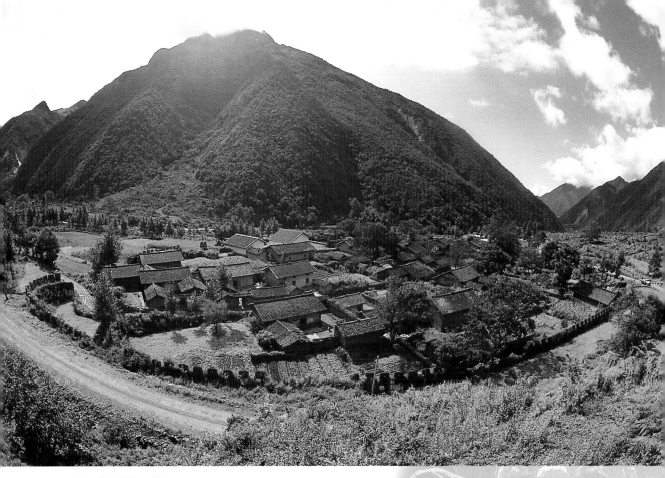

Dengxiangying Fortified Village, Xide

Xide and Dengxiangying Fortified Village

After the ancient Lingguan Road passes Yuexi, it enters Xide County. Here there is a tortoise-shaped fortified village called Dengxiangying. For 2,000 years, it defended the caravans against robbers right up until

There used to be a plank road along the cliff by the Lugu Gorge, through which the Sunhe River runs. It has been replaced by a modern highway. The small vertical characters below the large character "Dragon", reading, "The spring water can't be drunk," are said to have been written by Zhuge Liang.

The stable of an ancient dak

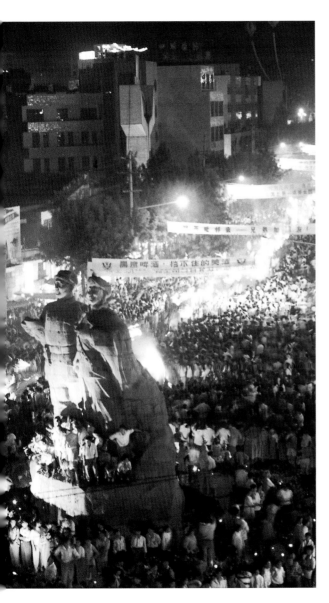

the early years of the Republic of China (1911-1949). Every three days, the troops would escort a caravan along the road. Along this route of a dozen kilometers from there, tumbled-down walls are still visible. The road paved with gravel is said to be built in 1763 under the reign of Emperor Qianlong. A fire in modern times destroyed the remaining buildings inside the fortified village. Many of the local people are descendants of garrison soldiers.

Xichang, the Moon City, and Torchlight Festival

Xichang lies in a plain surrounded by mountains south of the Lugu Valley. China's satellite launching base is only 70 km south of this capital of the Liangshan Yi Autonomous Prefecture. On the site of the ancient Kingdom of Qiongdu and part of a vital communications route, Xichang has been the prefecture's capital in each dynasty since the Han. Caravans from every direction used to rest here. There is a lake called Qionghai Sea or Qiongchi Pool nearby, which covers an area of 31 sq km. The Qionghai Sea

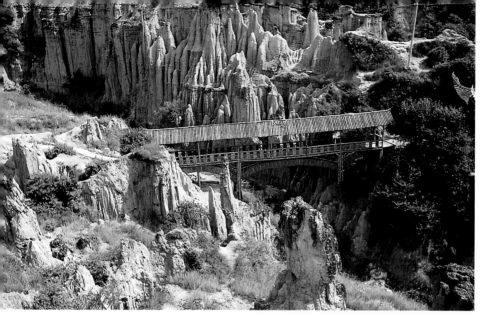

A wonderful forest of peaks

The old city walls of Xichang

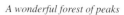

These steles in the Guangfu Temple record details of earthquakes in the area.

is famous for its beautiful sight at night "when the moon climbs over the Qiongchi Sea, it brightens the highest heavens" according to an ancient poem. So Xichang is also called the Moon City.

The celebration of the traditional Torchlight Festival by the people of the Yi nationality lasts for three days from the 24th day of the sixth month by the lunar calendar. Although the residents of Xichang are mostly Han, they observe this festival together with the Yi people. As to the origin of the festival, one story goes that long ago the people used torches to drive away pests sent by a malevolent deity to eat up their crops.

The Custom of the Yi People of Zhaojue

The Liangshan Mountains are home to the biggest single community of the Yi ethnic group, numbering 1.35 million out of the total of 5.45 million Yi people in China. The Guhou and Qunie tribes of the Yi lived in the area of Zhaotong, Yunnan Province, 2,000 years ago, and migrated to Liangshan 1,600 years ago.

In a village in Zhaojue County, a Yi funeral was taking place. About noon, relatives of the family came from all around, and just before they entered the village, gunshots were heard—an exchange of salutes from guests and host. Young men and girls welcomed the guests to the village waving ceremonial flags. After the guests had paid their respects to the departed, they were served snacks in a meadow. Despite the solemn occasion, everyone wore their most colorful clothes, the designs of which varied with the different Yi clans. However, capes made of felt or wool were worn by all, young and old, male and female.

The deceased is normally cremated after lying at home for three to five days, and then a funeral ceremony is held. A priest known as a *bimo* is invited to chant scriptures and release the soul from purgatory. Such *bimo* is well versed in the Yi scriptures, which are written in the peculiar script of the group. The priesthood is hereditary.

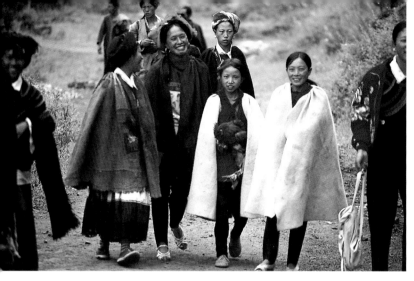

All Yi people, male and female, wear a cape called "cha'erwa" around their shoulders during the day, and use it as a blanket at night.

A bimo priest presides over a Yi funeral.

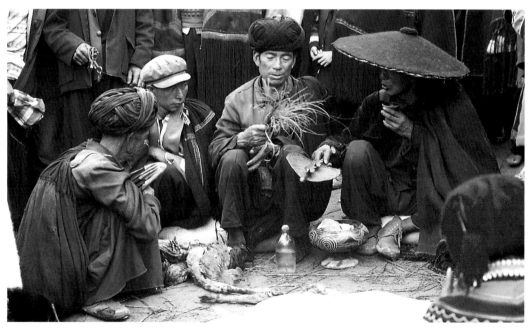

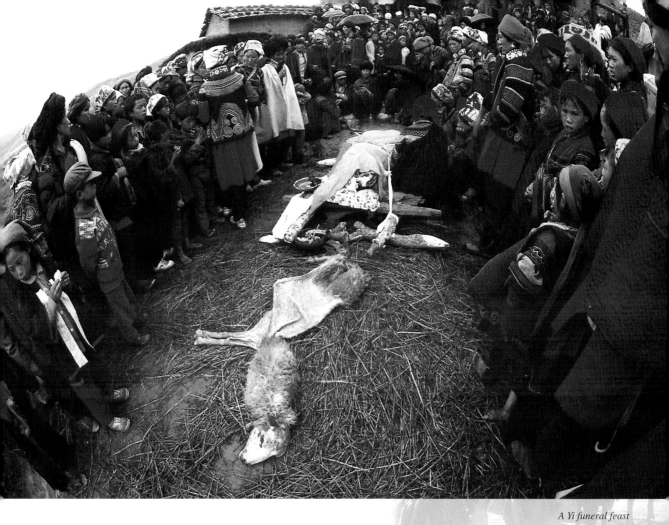

A Yi funeral feast

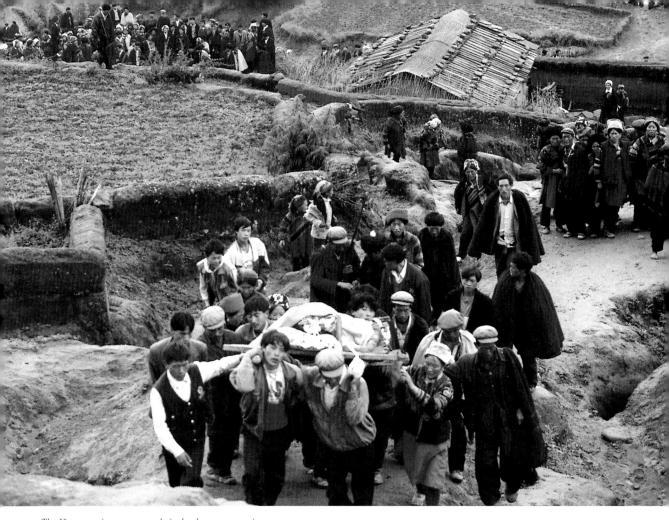

The Yi custom is to cremate their dead on a mountain.

" Ancient Runyan Road" are carved on the cliff face by the highway from Yanyuan to Xichang.

Yanyuan and the Ancient Runyan Road

The Southwestern Silk Road forks in the south of Xichang. One branch runs through Jingde and Huili to Dayao; the other connects Yanyuan with Dali via Lijiang. This latter road was referred to in the Ming Dynasty as "the Ancient Runyan Road." An inscription bearing the name of this route can still be seen on a cliff face on the ancient post road from Xichang to Yanyuan. Located at a strategic junction connecting Sichuan, Yunnan and Tibet, Yanyuan was named Dingzuo County in AD 129, in the Western Han Dynasty.

Yanyuan was so named because of the salt (*yan*) produced there, one of the oldest commodities for trade along the road. Other place names, Yandao, Yanbian, Yanjin, Yanxing and Yanfeng on this route are also related to salt production and transportation.

The white salt well and the black salt well described in Han and Jin Dynasty records can still be seen in Yanyuan, and salt production continues to be the main industry in Yanyuan County. Legend has it that a shepherdess of the Mosuo ethnic group was the first person to discover salt here in a spring at the foot of a mountain. She reported this to the chieftain of the tribe. Fearing that she might disclose the secret that the water had salt, the cruel chieftain killed the girl. To commemorate her, a temple was built.

The Matriarchal Tribe of Lake Lugu

Where the route of the Southwestern Silk Road crosses from Sichuan to Yunnan

The Drum Tower in the town of Dechang

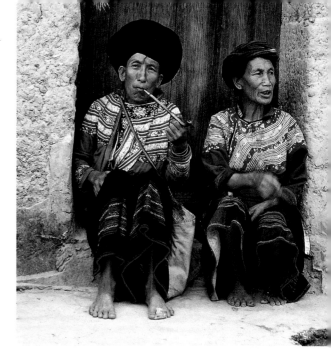

There are over 3,000 people of Lisu ethnic group in Dechang.

there is a plateau lake, the mysterious and beautiful Lake Lugu. Surrounded by mountains, the 72-sq-km lake lies at an altitude of 2,660 m above sea level. The wooden houses of the Mosuo people are scattered along the shore of the lake. In the courtyard house of a typical Mosuo family, the main hall functions as the dining, meeting and living room. Opposite the main hall, there is a two-story building used specially for bedrooms. Each grown-up female has a separate room for receiving her lover.

The Mosuo people still follow the matriarchal system, so each family is presided by its most prestigious and capable woman, who also arranges the family's economic and financial activities. Men never bring a wife home nor do women go to live with their lovers' families. At night, women receive their lovers at home, while the male members of the family go out to their sweethearts' home. The relationship between a man and a woman can last a few months or years, but they never form a family. All children belong to women, who bear their mothers' surnames, and inherit their mothers' property. The male members of a family are brothers of the grown-up women, and thus uncles of

the children. They help bring up their sisters' children and retain a special relationship with the children even closer than that with their fathers.

Dechang or Phoenix Town

The Silk Road stretches southward from Xichang for 64 km along the Anning River valley, flanked on both sides by towering mountains, before it reaches the county seat of Dechang. Following the ancient route along the river, the Chengdu-Kunming railway and Sichuan-Yunnan state highway run side by side. The Dechang County town is also called Phoenix

Town, after the Phoenix Tower, which is located in the northern part. There is also the hexagonal Bell and Drum Tower, 24 meters high and with upturned eaves. Inscribed on the horizontal board above the gate of the Bell and Drum Tower are the words "Extending to the capital in the north" on one side and, "Stretching to Mengzhao (Dali) in the south" on the other, evidence that this used to be a strategic part of the Silk Road and a key link between north and south in ancient times.

A bridge made of twisted bamboo cables is still in use in the valley of Laonianxiang. Such bridges were very common in ancient times, and now ropes made of rattan or twisted bamboo cables are mostly replaced by steel wire. The bridge extends some 70-80 m. Stepping on the thin planks which form the flooring, more than a dozen meters above a surging river, I felt dizzy, and marveled at the ease with which the local people, both old and young strode fearlessly across. It was people in this area who, in ancient times, built plank roads along cliffs to enable the Southwestern Silk Road to pass some of the most difficult terrain along the route.

Huili, a Small Town with a Myriad Tales

The ancient town of Huili still has its city walls and gates with a recently painted Drum Tower at its center and four city gates opening to the four directions. Shops line the flagstone-paved streets. Huili was once a hub of communications linking Sichuan with Yunnan and Guizhou for conturioo. Traders flocked here from all over China at one time. It is recorded that during the Qing Dynasty there were 10 guild halls for people from ten provinces including Yunnan, Guizhou, Hubei, Fujian, Jiangsu, Zhejiang and Guangdong. In 1841, there were 13 business firms, 2,960 households engaged in business and 7,239 people employed in trade. A common saying went that "there are 72 markets and every market has 72 trades." Huili abounds in local products, and among its 50 or more kinds of local specialties in the past there were white wax, yellow wax, indigo , sugar, ox hides, sheepskin and

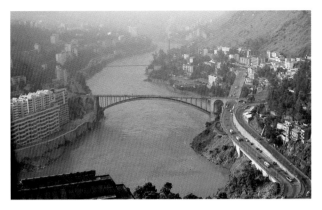

The Jinsha River runs through the city of Panzhihua.

opium.

Nowadays, to preserve the ancient atmosphere of Huili, the county government has taken steps to protect old houses, and new construction is permitted only outside the old city. At night, all the shops are brightly lit up, with fashion stores, shops selling household electrical appliances, hairdressing salons, song and dance halls and luxurious restaurants standing side by side with simple teahouses, bookstores, drugstores and blacksmiths' workshops, all open wide for customers. Snack stands line the streets.

Panzhihua, a New City of Iron and Steel

The Southwestern Silk Road crosses the Jinsha River at Lazhagu in Huili County. Then it reaches the border between Panzhihuan in Sichuan and Yongren in Yunnan. Towering over the scene is evergreen Fangshan Mountain, over 2,300 m above sea level. Legend has it that Zhuge Liang and his army crossed the Jinsha River at Lazhagu, and encamped on the Fangshan Mountain. Today, sites with names such as "Zhuge Camp," "General's Rostrum" and "Seven Star Bridge" are reminders of this historical episode.

Iron chain bridges are gradually being replaced.

In the 1930s, a deposit of magnetic iron containing at least 8.65 million tons and a coal seam containing over 100 million tons were discovered near here. Large-scale exploitation of these minerals began in the 1960s. The result was Panzhihua, a new city of 450,000 people, the largest iron and steel production base in southwest China.

Yibin, the Starting Point of the Wuchi Road

Yibin, the Starting Point of the Wuchi Road

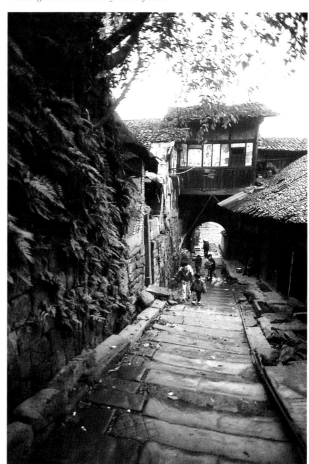

Water gate in the old city wall of Yibin

After Qin Shi Huang (first emperor of the Qin Dynasty) unified China in 221 BC, he had a road opened from the Sichuan Basin to the Yunnan Plateau. As the road was five *chi* wide (c.166 cm), it was called the Wuchi (five *chi*) Road. The Bo Road, built in the Han Dynasty, and the Shimen Road, built in the Tang Dynasty, were expansions based on the Wuchi Road. Starting from Yibin, Wuchi Road goes southward to Zhaotong, Qujing, Dianchi and Dali in Yunnan.

In ancient times, for transportation from Chengdu in the center of Bashu to Yibin people mainly relied on the Minjiang River. Situated at the confluence of the Jinsha and Minjiang rivers, Yibin is also referred to as "the first city on the Yangtze River," as the Jinsha and Minjiang flow into the Yangtze nearby. Yibin is the political, economic and cultural center of southern Sichuan, governing 10 counties with an area of 13,262 sq km and a population of five million.

Since ancient times, Yibin has been a trade center linking Sichuan, Yunnan and Guizhou, and a bridge for the transmission of advanced culture and technology from the Sichuan Basin and the Central Plain to the southwestern border areas. For two millennia the

Longhua Town was located in a key position on the Silk Road from Yibin to Leshan and Chengdu. The streets of the town are preserved just as they were in the Ming and Qing dynasties.

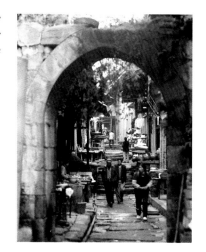

place was crowded with businessmen and their boats, as well as trading caravans. Copper, medicinal herbs and mountain products came from Yunnan and Guizhou to be exchanged for salt, wine, oil, tea, grain and silk from Sichuan. Goods were carried along the river to the Central Plain, through the Silk Road to Yunnan, and through the Tea and Horse Road to Tibet and even Southeast Asia, Myanmar and India. As recorded in 1910, the ancient road from Yibin to Kunming was 945 km long and would take a caravan 24 days to cover. There were over 8,000 horses carrying goods all year round on this stretch of the Silk Road.

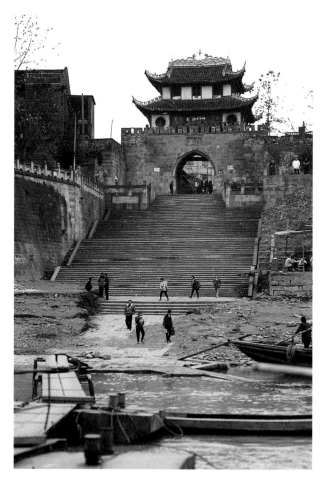

The only completely preserved old city gate tower along the Yangtze River is the Wenming (civilized) Gate Tower in Nanxi County.

A Town Famous for Its Liquor

Yibin is well known for its liquor. In fact, the Wuliangye Distillery covers an area of several sq km, making it even larger than the city proper. The most famous spot in the city is the Pool of Floating Cups, built by the Northern Song Dynasty poet Huang Tingjian in 1098, when he was living in exile in Yibin. He got the idea from an essay by the Eastern Jin Dynasty calligrapher Wang Xizhi, which mentions a drinking game in which wine cups are floated on a stream. By the pool can be found Huang's authentic calligraphy, and 98 poetic and calligraphic works by other celebrities of the Song, Yuan, Ming and Qing dynasties. In the city museum and the museum of the Wuliangye Distillery, there are exhibitions all the year round relating to the culture and history of liquor. The exhibits range from Han Dynasty stone inscriptions and pottery figurines to utensils for liquor production, storage, ladling, warming, etc. Drinking culture is fully covered, too, including varieties of alcoholic beverages, and drinking customs, songs and poems. In fact, Sichuan's liquor brands are famous throughout China. The best known brands from Sichuan are produced in areas with similar climate and soil to

Guizhou, where the world-famous Maotai and Dongjiu brands of liquor are produced.

The Mysterious Suspended Coffins of the Bo People

Known as Bodao County in the Han Dynasty, Yibin belonged to the State of Bo before the Qin Dynasty united China over 2,000 years ago. The Bo people were very diligent and gentle, and were known as the kindest among the tribes in the south according to historical records. They were good at planting fruit trees, especially lychee trees. They made great contributions in building the Wuchi Road. In the course of 11 campaigns by Ming Dynasty rulers over a period of some 200 years, the Bo people were exterminated.

Suspended on a cliff at Sumawan in Gongxian County are dozens of coffins over scores to 100 m above the ground. There are also hundreds of such coffins in the Matangba area. It is still a mystery how these heavy coffins were raised to such a height in ancient times and why.

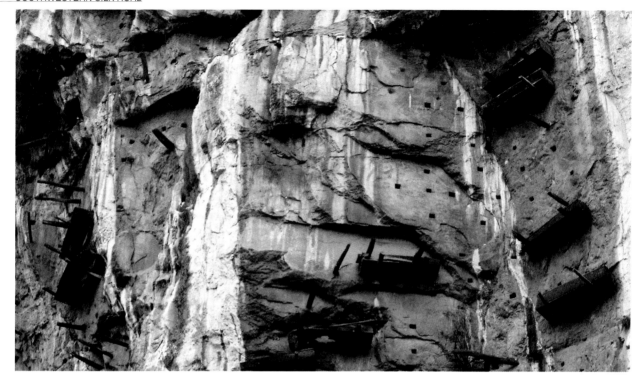

Suspended coffins of the Bo people at Sumawan

According to legend, a plague once struck the Bo people, and they were defeated in war. A brother of the chief, Aduan, consulted an sorceress, who told him that the reason for these calamities was that the bodies of their ancestors were not properly protected. She instructed him in the ceremonies he must perform to solve the problem. When Aduan carried out the ceremonies, a swarm of eagles came and turned into strong men in black clothes. They took the coffins of the ancestors, and rose in the air with them. Having fixed the coffins to the sides of the cliffs, the mysterious men turned into eagles again, and flew away.

Zhaotong, the Guanhe Valley

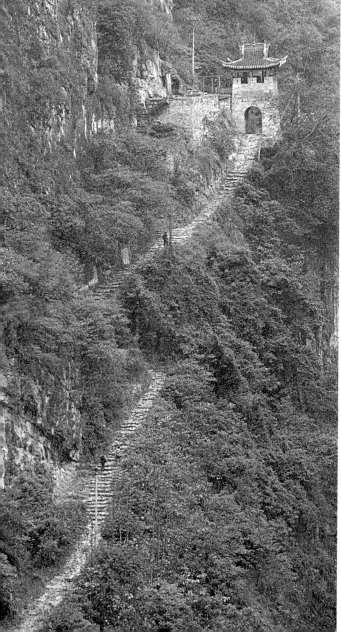

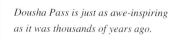

Dousha Pass is just as awe-inspiring as it was thousands of years ago.

Zhaotong, the Guanhe Valley

As was recorded in history, "The mountains are rugged and the valleys deep south of Yibin." Two routes stretch from Yibin to Yunnan: One is the waterway which goes west by the Jinsha River to its branch in Guanhe River Valley. Another is the land passage going south via Junlian. The two routes meet at Yanjin.

The Guanhe River Valley is long and narrow, and flanked by steep mountains on both sides. The altitude becomes higher and higher and the temperature lower and lower as it advances westward. After it passes Yanjin, the mountains are even more lofty and desolate, with no more bamboo groves or orange trees. A narrow footpath can be seen meandering up the steep slopes, the ancient Silk Road that follows the waterway. A modern highway runs basically along the old route, and every 20 km to 30 km a village, once the site of an ancient post house, can be found. In some sections, the flagstone road is still completely preserved, marked clearly by the ruts made by horses' hoofs. The Guanhe waterway gave access as far as Dousha Pass before the Tang Dynasty, but the journey had to be continued on land to Zhaotong, because of the swift current and dangerous shoals.

The topography of Zhaotong is high in the south-

west and low in the northeast. Shuifu County in the north is only 267 m above sea level, while Qiaojia County in the south is 4,040 m above sea level; Zhaotong, in the middle, is 1,949 m in altitude. The land route and waterway meet at Yanjin, which used to be a ferry used mainly for salt transport but is now a mountain city with a big population and a large number of tall buildings.

The Impregnable Dousha Pass

One of the most formidable passes on the Southwestern Silk Road is Dousha Pass, 20 km west of Yanjin. In this part of the Guanhe River Valley, the lofty mountains seem to have been cleaved open, and the flanks of the valley look like two giant stone gate posts guarding the pass, hence it is also called the Stone Gate Pass. A flagstone road about 1.5 m wide winds its way up one side of the steep cliff, the Wuchi Road, opened during the Qin and Han dynasties. At the most strategic point is the Dousha Pass, which was said to be a place where one man could hold out

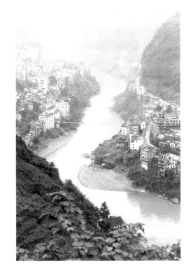

The county seat of Yanjin

Ruts left by horse's hoofs on the Southwestern Silk Road near Dousha Pass

against ten thousand. There used to be a memorial arch at the pass inscribed with the words "The First Pass in Southern Yunnan." Overlooking the surging Guanhe River, the pass is still as imposing as it always was.

At the Dousha Pass there is a stele in a pavilion. The stele bears an inscription written by Yuan Zi, an envoy of the Tang court to the Kingdom of Nanzhao in AD 793. The inscription is a record of Yuan Zi's journey and his success in restoring friendly relations

The ancient Southwestern Silk Road in the Daguan area

between the central government and this border area. Yuan Zi bestowed a golden seal on Yimouxun, recognizing him as the ruler of Nanzhao.

A small bronze horse unearthed at Daguan

Delighted, Yimouxun presented Yuan Zi with magnificent gifts, and escorted him as far as the Dousha Pass.

The Bronze Basins of Zhuti

Daguan County is a mountainous area, where the houses are all built on slopes. Preserved in its cultural center are two colored glaze balls. According to experts, they most probably came from India, as rare evidence of goods transported along the Southwestern Silk Road. There are also some Han Dynasty bronze basins inscribed with the words "bronze basin of Zhuti." In the Han Dynasty, bronze wares produced in Zhuti (today's Zhaotong) and Tanglang (today's Qiaojia, Huize and Dongchuan areas) nearby were widely known as Zhuti-Tanglang wares. Fish, egret, sheep, flowers and other inscriptions are common designs on such items. Zhuti is also well known as

the home of high-quality silver, which was produced in large quantities for the manufacture of the currency of the Eastern Han Dynasty.

Following the Silk Road through the valley and over one mountain after another, our car reached a vast low-lying plain—Zhaotong *bazi. Bazi* in the local dialect means low land embraced by mountains. It is estimated that there are 1,442 *bazi* of over one sq km in Yunnan with a total area of 24,000 sq km or about 6% of the total area of Yunnan Province. With rich arable land and concentrated population, *bazi* are usually where the county or prefecture seat is located, as the political, economic and cultural centers of their respective regions. Along the Southwestern Silk Road, the central areas of Zhaotong, Qujing, Kunming, Chuxiong, Dali, Baoshan and Ruili are all located on *bazi*.

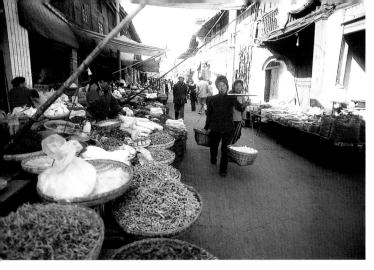

Zhaotong is renowned for its old streets.

This iron chain bridge over the Guanhe River was built in 1833.

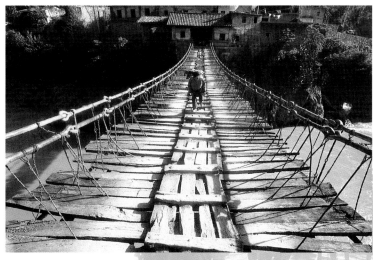

Stele of Meng Xiaoju, the oldest Han Dynasty stele so far discovered, was erected in AD 157. This is also the only Han Dynasty stele found in Yunnan Province.

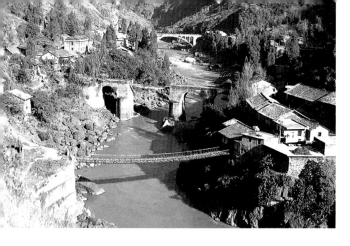

The three bridges at the boundary between Luxun and Huize counties in Jiangdi Town are made of iron chains, stone and cement, respectively, and were built in the Qing Dynasty, the Republic of China and the 1970s.

A Qing Dynasty picture of a Buddhist rite found and preserved in Shuifu County

The courtyard in the old house of a wealthy man in Zhaotong

In Luxun County there is an important community of the Hui people, whose ancestors first came as soldiers with Kublai Khan's southern expedition in 1253. The Hui are Moslems, and they remained here and engaged in farming.
An Islamic funeral ceremony of the Hui people.

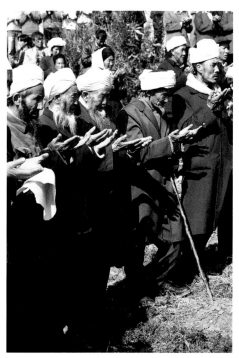

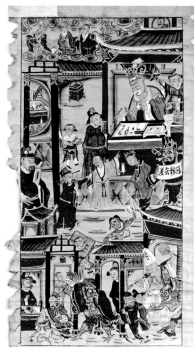

Weining and the Ancient State of Yelang

Six Arch Bridge, on the ancient Southwestern Silk Road

Weining and the Ancient State of Yelang

Present-day Weining County in Guizhou Province, a dependency of the State of Yelang in ancient China, stretches southeast from Zhaotong along the Wuchi Road.

When Emperor Wudi of the Han Dynasty dispatched an envoy to Yelang in 122 BC, the king of Yelang asked the envoy: "Which is bigger, Han or Yelang?" Later, the "ludicrous conceit of the king of Yelang" has become an idiom to ridicule an arrogant person with a very narrow view or limited outlook. Yelang was actually a large state in southwest China, covering present-day Guizhou, northwestern Guangxi, eastern Yunnan, and the southern border area of Sichuan. It lasted approximately 200 years, from the end of the Warring States Period to the early Western Han Dynasty. The State of Yelang regarded bamboo as its totem, as its founding myth describes the discovery of a baby boy inside a bamboo tube floating down a river. A woman washing clothes by the riverside happened to see the bamboo tube. She was unable to push it away. Then she heard a baby crying inside the tube. She brought it home and broke open the bamboo tube and found a boy. The boy was named Zhu (bamboo), and grew up to be the first king of Yelang. According to historical

records, Emperor Wudi of Han paid great attention to Yelang, dispatching envoys several times with gifts of grain and silk. Later, he annexed Yelang and put it under the jurisdiction of Qianwei Prefecture. In 25 BC, an independence movement in Yelang was crushed by Emperor Cheng of Han.

Caohai, Jewel of the Grasslands

Caohai (Sea of Grass), known as the "Jewel of the Grasslands," lies on the edge of Weining County. It is 2,200 m above sea level, and its water surface

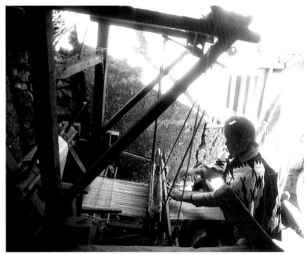

Weaving, embroidering and sewing are essential skills for every Miao woman.

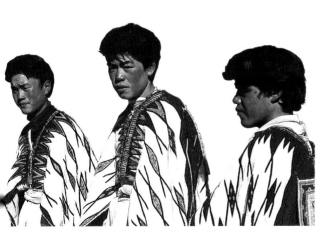

covers an area of 45 sq km. An ancient bridge called the Six Arch Bridge is a famous spot for sightseeing. A poem praising the eight scenic spots of Weining has a line which goes, "An immortal descended to the misty willows by the Six Arch Bridge." It is said that once a Taoist surnamed Jiang met Lü Dongbin, one of the Eight Immortals, among the misty willows. Water plants grow luxuriantly in Caohai, which is home to over 120 varieties of birds, including black-necked cranes, which flock here in winter.

Miao people in Weining, wearing their traditional costume

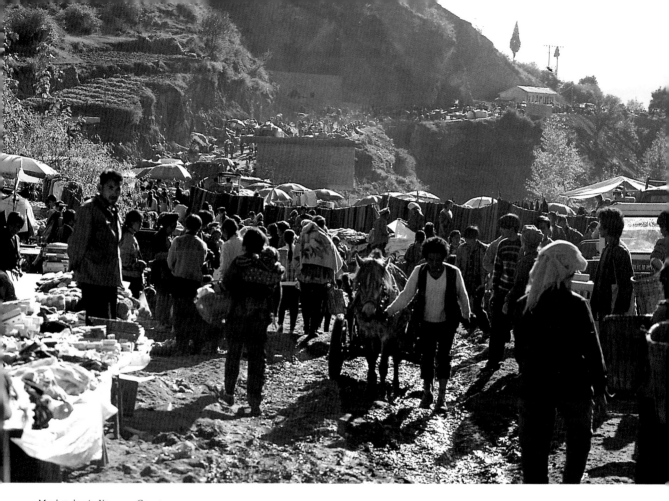

Market day in Yancang County

*A typical tomb of the Yi
ethnic group of Yancang*

The Ancient Religious Lore of the Yi People

The primitive religious sacrificial rites of the Yi ethnic group were presided over by a shaman, called a *bimo*. In the past, the Yi would always ask a *bimo* to make a divination before embarking on a battle, a hunt, a journey or a marriage, or building a house. There are still 20 *bimo* in Weining County. Li Yaolin, who worked for the Committee of Ethnic Groups and was born into a hereditary *bimo* family, learned how to conduct the rites from his father. He is also qualified to conduct various rites. However, as society progresses, such activities have been greatly reduced.

The ancient books of the Yi are all hand-written copies. They contain information handed down through the ages, with no indication as to the author or authors, or when this lore was first committed to writing. The texts are mainly in the form of verse, with five or seven characters to a line. These books serve as encyclopaedias, covering astronomy and the calendar, geography, medicine, military affairs and passages from religious scriptures. Many books have exquisite illustrations. There are over 1,200 such col-

The ancient Shimenkan Road

lections of ancient folk wisdom in existence, of which some 1,000 are at least 100 years old. Some ancient books in Yi language have been published after being translated into Chinese since the 1950s. During the "Cultural Revolution" (1966-1976), these books were regarded as vehicles of superstition, and many were destroyed. Li Yaolin has been engaged in editing these ancient books in Yi language in recent years to preserve the ethnic group's precious cultural heritage.

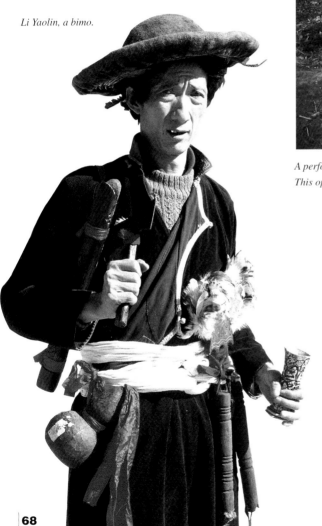

Li Yaolin, a bimo.

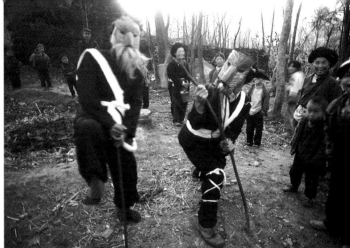

A performance of Nuoxi, the traditional opera of the Yi ethnic group. This opera originated in primitive fertility sacrifices.

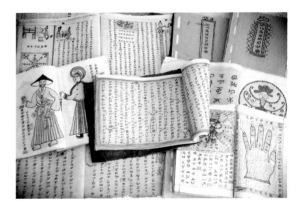

Ancient books of the Yi

Qujing, City at the Source of the Pearl River

Source of the Pearl River

Qujing, City at the Source of the Pearl River

Going southward from Weining along the Wuchi Road, one reaches Qujing, known as Weixian during the Tang and Han.

Qujing is the hometown of Ashima, a legendary beauty. A statue of Ashima stands in a street. It is also the place where Zhuge Liang, prime minister of the Kingdom of Shu during the Three Kingdoms period, captured Meng Huo seven times. A group of large reliefs at the roadside depict the epic history of that time.

Mt Maxiong lies 80 km from the city. It soars 2,444 m above sea level and is covered with trees. The source of the Pearl River is here, in a deep cave with stalactites. The Pearl River's water yield is next only to that of the Yangtze River and eight times that of the Yellow River. With a total length of 2,197 km, it is the fifth-longest river in China, flowing through Yunnan and Guizhou provinces, and Guangxi Zhuang Autonomous Region, to form the Pearl River Delta in Guangdong Province.

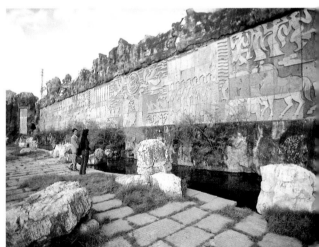

Huge reliefs depicting the exploits of Zhuge Liang of the Three Kingdoms period

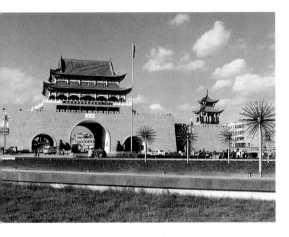

The newly renovated gate tower of Qujing City

The Cuanlongyan Tablet, 3.88 m high, bears an inscription of over 900 words.

Unique Cuan Calligraphy

Qujing is most famous for being the site of the "Two Cuan Tablets." Cuan is the name of an unusual type of calligraphy. The Cuanbaozi Tablet, erected in AD 405, during the Jin Dynasty, is now in the No.1 Qujing Middle School. The Cuanlongyan Tablet, erected in AD 458, during the Southern Dynasties period, is now in the Zhenyuanbao Primary School of Luliang County. The former, which is smaller, is called Xiaocuan, and the latter, Dacuan. The tablets have been highly praised by calligraphers of every epoch. Cuan was the name of a powerful family which dominated the Nanzhong (present-day Yunnan and Guizhou provinces) area for some 500 years, until it was subjugated by Zhuge Liang.

Xuanwei Ham and the Kedu River

Xuanwei achieved fame when Sun Yat-sen was offered some ham by Pu Zaiting, a Guangzhou manufacturer, and praised it highly. The product went on to win a gold medal at the 1904 Panama International Exhibition. Since then, Xuanwei ham has been exported to Southeast Asia, Japan and European countries. China's late senior leader Deng Xiaoping was the son-in-law of Pu Zaiting.

Xuanwei stands on the boundary between Yunnan and Guizhou provinces. An ancient two-meter wide road paved with slabstones winding on mountains connects Weining in Guizhou with Xuanwei of Yunnan, and it is still well preserved. For centuries, travelers had crossed the Kedu River ("river that can

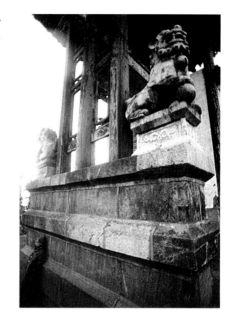

The complexions of the stone lions on either side of the Shengjing Pass Memorial Archway are obviously different.

be crossed") by ferry, but in 1917 a 60-meter long, three-arch stone bridge was built over the river. The ruins of the Kedu Pass of the Ming Dynasty situated by the ancient road on the southern bank, among many other ancient relics, are still preserved. Many of the ancestors of the over 250 local households were garrison soldiers from the inland regions.

Fuyuan County

Fuyuan County is where the pass, known as the Shengjing (Heavenly Scenery) Pass, through which one enters Guizhou Province from the east, is located. Xuanwei Ridge marks the boundary of Yunnan and Guizhou provinces. Interestingly, the soil in Guizhou, which is subject to misty weather, is dark brown, while that in Yunnan, which has clearer weather, is of a bronze color. On the border stands a memorial archway dating from the Ming Dynasty, 12 m in height and 10 m in width. On it are inscribed characters meaning "Beautiful Scenery of Southern Yunnan." Pairs of stone

Approaching the ancient road and tower of the Shengjing Pass from Guizhou.

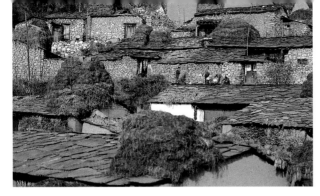

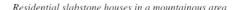
Residential slabstone houses in a mountainous area

The ancient Huize road, built for transporting copper ore

lions face Guizhou and Yunnan, respectively. The lions on the side of Guizhou are covered with moss whereas the pair on the side of Yunnan are covered with brown dust only. A local saying goes, "The God of Rain loves Guizhou, while the God of Wind loves Yunnan."

East of the archway stands the Shiqiu (stone dragon) Pavilion, erected during the Ming Dynasty, in front of which lies a rock which looks like two intertwined dragons. Legend has it that a male dragon living in Yunnan and a female dragon living in Guizhou were transformed into human beings. They met by accident at Shengjing Pass, where they fell in love at first sight. Since they could not decide whether to live in Yunnan or Guizhou, they turned into intertwined stone dragons, turning their heads to their respective native land.

Approximately 500 m east of here is the Qing-dynasty tower of the Shengjing Pass. The tower was partially rebuilt in 1990.

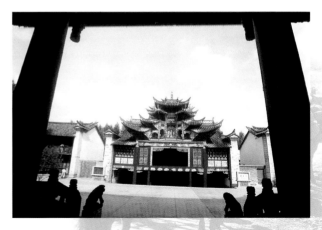
Stage for traditional performances in the Jiangxi Guild Hall (also called the Wanshou Palace) in Huize

73

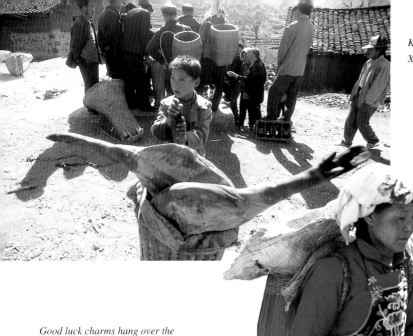

*Kedu Village on a market day.
Xuanwei ham is a famous local product.*

*Good luck charms hang over the
entrances of the houses of the village.*

A child selling a chicken in the market.

Foot-binding is still practiced in Xuanwu.

Kunming, Center of the Ancient "Yunnan Culture"

Kunming, Center of the Ancient "Yunnan Culture"

It was by no means accidental for Kunming to become an important city on the ancient Southwestern Silk Road. First of all, due to its geographical position, it is the transportation hub of eastern, western and southern Yunnan Province. Secondly, it is richly endowed by nature, with a climate which seems like spring all the year round.

The beauty of Kunming, capital city of Yunnan Province, is acknowledged by all who have visited it. The 2000 World Horticulture Exposition helped to spread its fame far and wide.

According to historical records, the fertile Yunnan

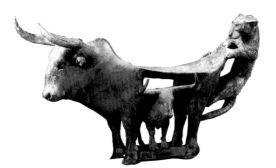

Ox-and-tiger-shaped bronze table of the Warring States Period, unearthed at Mt Lijia, Jiangchuan County (Photo by Xing Yi)

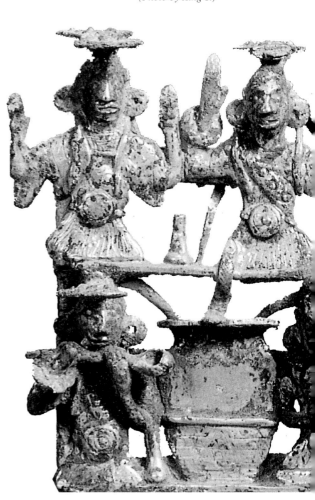

Biji Pass, which used to give access to Kunming from the Silk Road, lies under a modern expressway.

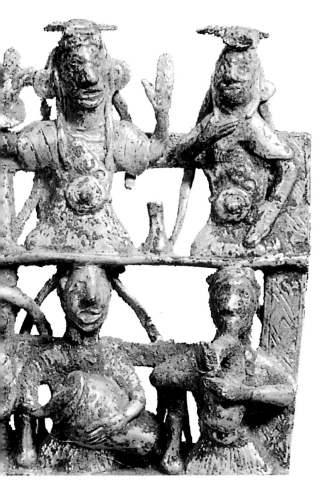

area was conquered by the State of Chu during the late Warring States Period. The occupation of what is now Sichuan and Guizhou by the rival State of Qin left the Yunnan region cut off from Chu. As a result, the State of Dian arose there, around Lake Dian.

Due to its distance from the Central Plain, Yunnan has been less influenced by Han culture, perhaps, than Sichuan. Situated on a plateau, Yunnan is characterized by thousands of small valleys separated from each other by steep mountains. A number of different ethnic groups inhabit the valleys, which are characterized by a diversity of natural features and endowments.

A number of bronzes of the late period of the Yunnan Culture found in tombs of the ancient Yunnan Culture are on display in the museums at Mount Shizhai in Jinning and Mount Lijia in Jiangchuan. They have been acclaimed by experts for their exquisite

77

This stone pillar, 8.3 m high and bearing a Buddhist inscription and 300 carvings, is a relic of the State of Dali (937-1253), in present-day eastern Yunnan.

shapes and advanced casting technique. Over 300 tombs of the Yunnan Culture have been discovered, from which more than 7,000 bronze objects in over 90 varieties have been unearthed. They were produced in various historical periods spanning over 1,000 years, corresponding to the period from the Western Zhou Dynasty to the Western Han Dynasty. Sima Qian's *Biography of the Barbarians in Southwest China* is the first written record of Yunnan Culture, and reveals that there were two different cultures during the Western Han Dynasty—Yunnan Culture centered on Lake Dian, and Kunming Culture of the present-day Baoshan and Dali areas of Yunnan Province.

In Yunnan Culture tombs, precious objects such as colorful glazed ornaments and silver buttons with winged tiger patterns produced in Pakistan and Iraq, and some implements made in inland China, including silk fabrics, kettles with hoop handles, bronze mirrors and coins have been discovered. These are clear evidence that the Silk Road in southwest China was already a far-reaching artery of trade.

Chuxiong, Cradle of Prehistoric Man

Xingxiu Bridge in Lufeng, first built in 1615 during the Ming Dynasty, with a length of 96.5 m, was once the only way to reach the western part of Yunnan.

Chuxiong, Cradle of Prehistoric Man

Sixty km west of Kunming, on the ancient Southwestern Silk Road, lies the Yi Autonomous Prefecture of Chuxiong. The prefecture has a total area of 29,000 sq km, and a population of 2.45 million. Situated between Lake Dian near Kunming and the Erhai Sea of Dali, it was a strategic pass for two main highways forming the Silk Road in the area; from east to west, from Chuxiong to Kunming along the Wuchi Road, passing through Lufeng in the east, and to Dali through Nanhua and Xiangyun in the west; from south to north, from Mt Liangshan in Sichuan Province to Yongren and Dayao in the Chuxiong area along the Lingguan Road, following the Jinsha River, and finally reaching Dali through Xiangyun.

It happened to be the 40th anniversary of the Yi Autonomous Prefecture of Chuxiong when I arrived in the area. People of the Yi, Han, Miao, Hui, Dai, Bai and Lisu ethnic groups of the one city and nine counties under the prefecture's jurisdiction had gathered for a celebration.

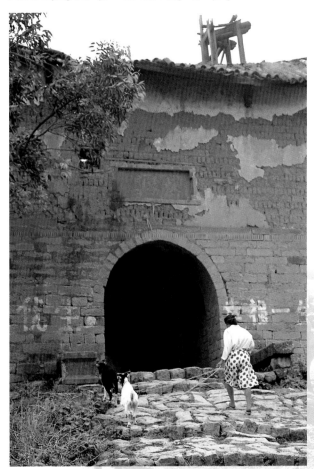

Ruins of the fortifications which once guarded the Lianxiang Pass in Lufeng County, between Kunming and Lufeng

Cradle of the Human Race

Chuxiong is one of the birthplaces of the human race, according to a series of important archaeological discoveries made in the area: From 1975 to 1980, fossils of the Lama Ancient Apeman, who lived approximately eight million years ago and was a proto-human, were unearthed in Lufeng County; in 1965, fossils of the teeth of Yuanmou Man, the earliest human beings, who lived 1.7 million years ago (one million years earlier than Peking Man) were found in Yuanmou County; in 1972, New Stone Age ruins were found in the Dadunzi area of Yuanmou County; and in 1975, ancient tombs of the Spring and Autumn and the Warring States Periods were excavated in Wanjiaba in the Chuxiong area, yielding the oldest bronze drum so far discovered in the world. This series of discoveries indicates that Chuxiong was an important area of the evolution of early man. In addition, the fossils of 18 complete dinosaurs have been unearthed in Lufeng County since 1938.

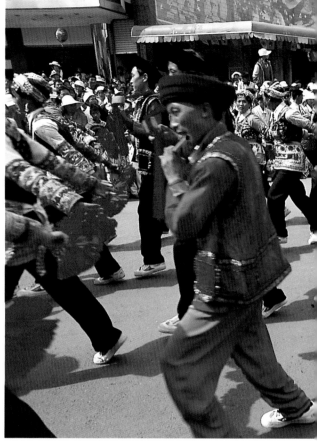

The bronze drum unearthed at Wanjiaba in the Chuxiong area is the oldest of its kind so far found.

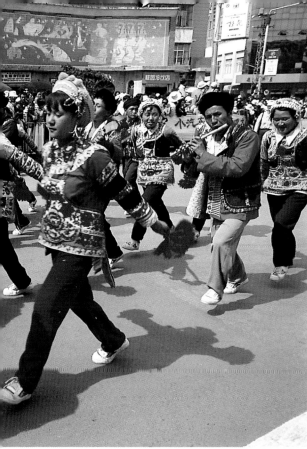

People of the Yi ethnic group from various areas
gather at Chuxiong for a traditional festival.

Legend of the Costume Festival

The costume festival, a traditional festival of the Yi ethnic group of Santai Township of Dayao County, is celebrated on the 28th day of the third month by the lunar calendar. During the festival, Yi women in brightly-colored dresses are as picturesque as flowers in the streets and markets, and on mountain paths. In the evening, young women and men dance all through the night. Lovers whisper on the slopes and in the groves.

It is said that long ago, a chief called young men living in 18 stockaded villages on nine mountains together to compete in riding, shooting and other military skills. The winner would be made a general, and allowed to select a beautiful girl to be his wife. When a young man named A Daxi won the first prize, the chief wanted to marry him to his own daughter. But A Daxi asked to marry his sweetheart A Mini. The chief then declared that a contest would be held, and A Daxi would marry the girl with the prettiest costume. The chief then engaged 99 best tailors in the region to make clothes for his daughter with the best materials. How could A Mini, who was a poor girl, hope to compete? That night, having sobbed herself to sleep, holding a golden pheasant captured for

Teeth of the Lama Apeman unearthed in Lufeng County.

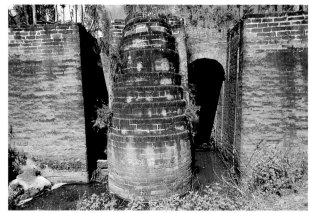

her by A Daxi, she dreamt that she herself had turned into a beautiful golden pheasant. Drawing inspiration from the dream, the next day she sewed a glittering dress as beautiful as the feathers of the bird. It was acclaimed by all to be the best costume, and the chief had to agree to marry A Mini to A Daxi. But he tricked A Daxi by substituting his third daughter for A Mini on the wedding night. A Mini turned into a golden pheasant flying off to the woods. Chasing her, A Daxi also became a golden pheasant....

This stone dyke in Yao'an County, constructed 1335-1340 during the Yuan Dynasty, is still intact.

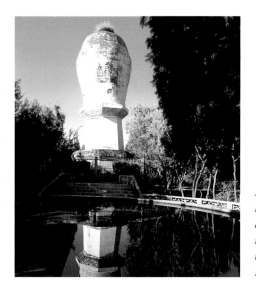

Such festivals and gatherings are rare opportunities for young men and women of the Yi nationality, who live in secluded valleys, to meet and conduct courting rituals. The girls change their clothes frequently on the dancing ground, some as many as five or six times a day.

Dayao White Tower. This 18m high tower is in the rare shape of an inverted bell. An inscription attributes its construction to the monk Wei Chi of the Tang Dynasty.

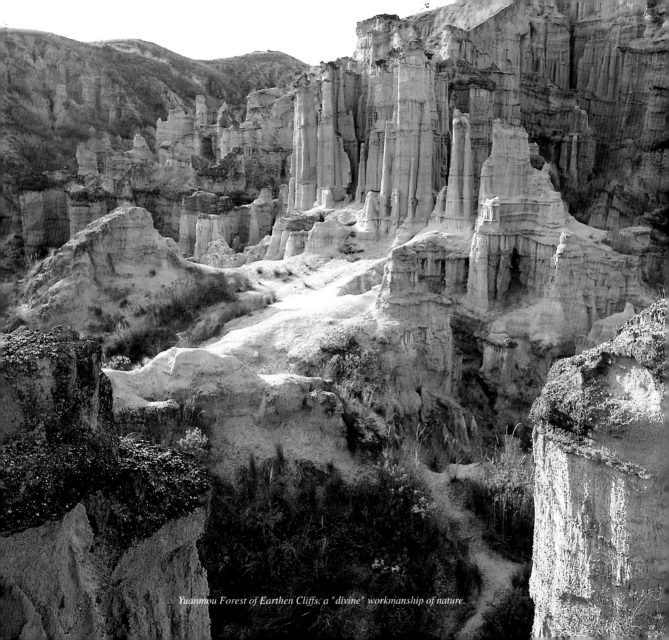

Yuanmou Forest of Earthen Cliffs, a "divine" workmanship of nature.

A stockaded village of the Yi ethnic group of the Nanhua area

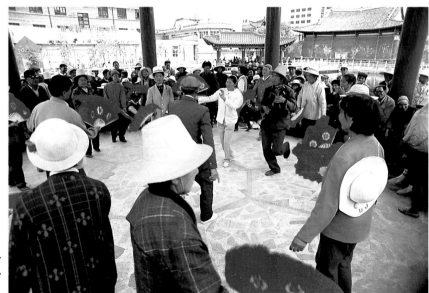

The traditional Huadeng folk opera of the Yao'an area is kept alive mainly by older people these days.

Yongchang Road, the Road That Cuts Across the Hengduan Range

Yongchang Road, the Road that Cuts Across the Hengduan Range

Chase Clouds to Xiangzhou

The Lingguan route on the west part of the ancient Silk Road and the Wuchi Road on the east part of the ancient Silk Road converge at the place where "colorful clouds appear in the south," or present-day Yunnanyi (*yi*: ancient courier station) in Xiangyun County, Dali Prefecture.

It is said that Emperor Wudi of the Western Han Dynasty got to know that to the southwest of the frontier there was an ancient road which led to India. He was very pleased to learn that and often looked up at the sky. From time to time, he saw colorful clouds hovering in the southern sky. He believed that that was a good omen, so ordered his men to follow those clouds moving south. His men chased the clouds until they reached the Yunnan dak. So the Han court set up the Yunnan County there, centered on Yunnanyi. In the Tang Dynasty, the name was changed to Xiangyun (auspicious clouds) County. Nowadays,

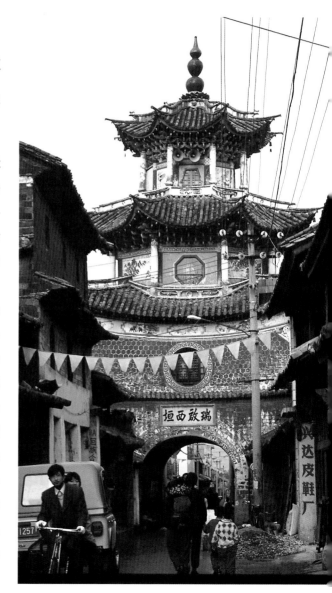

Xiangyun Bell and Drum Tower, built in the Hongwu reign period of the Ming Dynasty (1368-1398), is about 25 m high. The four gates of the tower bear the respective inscriptions "Brilliance Reflected on the Eastern Wall," "Splendor Radiating from the Southern Clouds," "Propitious Omens Starting from the Western City" and "Benevolence Carrying on to the Northern Palace."

Yunnanyi used to be a strategic location on the Southwestern Silk Road.

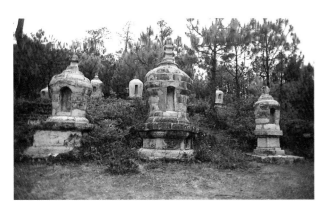

There are over 50 pagodas containing the remains of monks at the Shuimu Temple on Mount Shuimu. The temple was built in AD 813.

Yunnanyi is no longer a county seat, but a quaint and sleepy little town with an abiding sense of history.

After converging at Xiangyun County, the Silk Road extends westward to Dali. From there, it forks into the main road, namely, Yongchang Road, which passes through Yongping, Baoshan, and Dehong, and enters Myanmar and India, and a branch road (also named the ancient tea and horse road) which stretches northwest through Heqing, Lijiang, Zhongdian (now also named Shangri-La), and Tibet, and finally enters India.

Cultural Relics of Nanzhao

Dali, the starting point of Yongchang Road, is now

Set up in the Tang Dynasty, the Dehua Tablet is 3.97 m high and 2.46 m wide. It records the early history of the Kingdom of Nanzhao and its relations with the Tang Dynasty.

the capital city of the Dali Bai Autonomous Prefecture, administering 12 counties and cities. Dali has a long history. As early as 3,000 years ago, the forefathers of the Bai people lived in the area of Erhai Lake. Two hundred BC, people inhabiting this area were known as the Kunming, who lived on fishing and hunting. In the year of 109 BC, the Han Dynasty court sought a road through there to India but were hampered by the local people here. Emperor Wudi of the Han Dynasty trained waterborne troops, who in 109 BC conquered the Dian Kingdom and reached Erhai Lake, where they subdued the Kunmin people and set up Yeyu County. Crossing Mount Bonanshan (today's Mount Yangping) and the Lancang River, they set up Yongchang Prefecture, forming the southwest Silk Road for the first time. Starting in the 740s, the Kingdom of Nanzhao arose in this area. Nanzhao was succeeded by the Kingdom of Dali. In total, there were independent regimes here for five centuries. In 1253, leading an army of 100,000 men, Kublai Khan, the first emperor of the Yuan Dynasty, advanced south by way of the Qinghai-Tibet Plateau, used inflatable leather rafts to cross the Jinsha River, and wiped out the Kingdom of Dali. During the Kingdom of Nanzhao, Dali was the political, economic and cultural center of Yunnan, and today there are many places of interest there connected with the history and culture of Nanzhao. At the same time, Dali was also a center for cultural exchanges between China and Southeast Asian countries, as well as of trade and business. In the market town of Xizhou near Dali, more than 1,000 families of the Bai nationality live in a compact community. Before the 1950s, about 90 percent of these people were engaged in selling Yunnan tea to Sichuan Province, and Sichuan silk to Myanmar.

Once the capital of the Kingdom of Nanzhao, the Weishan County town was one of the first towns established in what is now Yunnan Province. The extant city wall was built in the Ming Dynasty.

Typical Bai houses in Xizhou, with carved beams, painted rafters, upturned eaves, arches, screen walls and gables decorated in gorgeous colors

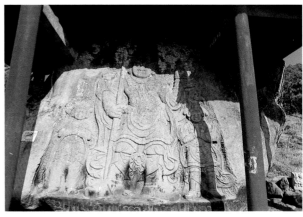

Statue of a general on Mount Jinhua

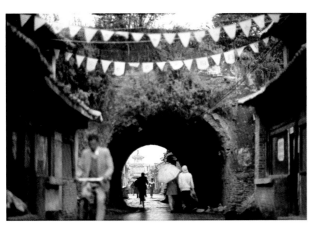

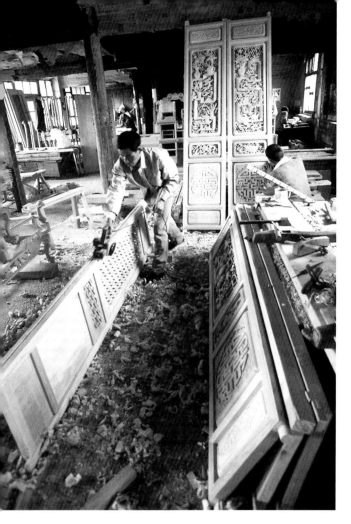

The carpenters of Jianchuan are renowned for their skill.

Carved out in the period spanning the Kingdom of Nanzhao and the Kingdom of Dali, the 16 grottoes on Mount Shizhong in Jianchuan contain 139 statues altogether. The statue in the eighth cave represents Yimouxun, the sixth king of Nanzhao, who was granted the title of King of Yunnan by a Tang emperor.

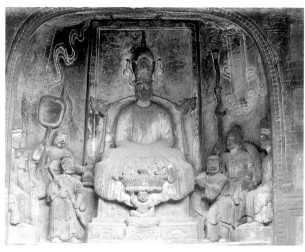

Shrined in the cave is a female reproductive organ for worship. Bai women come to this cave to burn joss sticks and pray for children.

A girl of the Bai nationality in Dali in a holiday mood

Splendid March Scenery of Dali

The scenery of Dali is well known for the "wind in the lower pass," "flowers on the upper pass," "snow on Mt Cangshan" and "moon on Erhai Lake." In Dali, the typical flowery headgear of the Bai girls are symbolic combination of "wind, flower, snow and moon." Three quarters of the total Bai population of China live in the Dali area. They possess exceptional capacity in architecture, sculpture, handicrafts and painting. For example, the wood-carving of Jianchuan, and the cloth-dying and marble crafts of Dali are already world-famous. The residences of the Bai people are mostly tile-roofed houses, with the walls made of rammed earth and wood. The typical layout is "three chambers with a screen wall" or "one chamber each on the four sides of a courtyard with five skylights." Stressing the beautifying role of the screen wall and arch in architecture, the Bai people show quite a high artistic level.

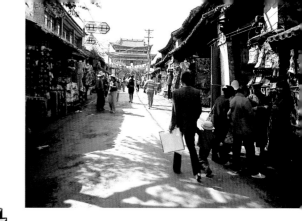

The tea and horse market in Dali has been flourishing since the Tang Dynasty.

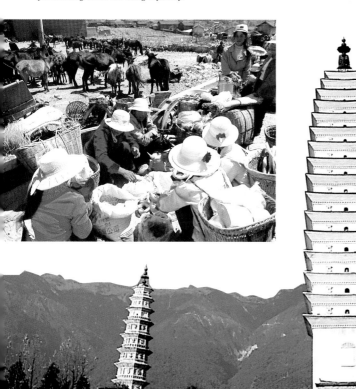

The ancient city of Dali still preserves the atmosphere of its distant past.

Constructed during the Fengyou reign period of the Kingdom of Nanzhao (823-859), the Three Pagodas in the grounds of Chongsheng Temple are a reminder of Dali's brilliant ancient culture.

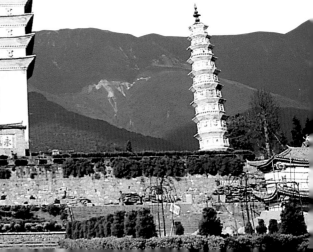

In Dali, in the third month by the lunar calendar every year, a Street Festival is held. This festival lasts five to seven days, and has a history of more than 1,000 years. It was the main occasion for tea and horse trading on the ancient Southwestern Silk Road. According to the *Records of Dali County*, compiled in the late Qing Dynasty, the volume of business was of a considerable scale — worth up to several hundred thousand ounces of silver. The number of merchants from all parts of China, as well as from countries in Southeast Asia, could number as many as 100,000. They came to trade in horses and mules, medicinal materials, tea, silk and cotton, woolens, timber, and pottery, bronze and tin wares. Nowadays the Street Festival is more lively than ever before. In addition to the prosperous trading, there are national artistic performances of singing and dancing, and traditional operas, along with dragon-boat racing and horse racing. In recent years, business people and tourists from both at home and abroad participating in the festival have reached over one million.

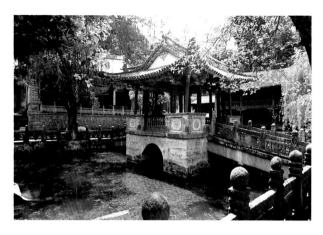

Wenchang Palace was first constructed in the Ming Dynasty as a school. In the courtyard there are platforms and ponds, and in front of the main buildings there is a marble road carved with dragon patterns.

This fresco shows a singing competition of the ancient Yi nationality.

The Ancient Bonan Mountains Road

Journeying westward from Dali along Yongchang Road, crossing Yunlong Bridge in Yangbi County and going deep into the Bonan Mountains area, the Silk Road reaches Yongping County (known as Bonan County during the Han Dynasty). Soaring 2,704 m above sea level, the Bonan Mountains are covered with thick forests. Deep gorges and steep paths make this the most difficult part of the road.

Shanyang, located in the heart of the Bonan Mountains, was an important courier station and distribution center for goods and materials on the Southwestern Silk Road in ancient times. It is recorded that as long ago as 100 BC the Dali area was famous for its caravans. In the 1950s, there still remained 3,000 km of ancient roads here, on which more than 200,000 counts of horses and mules carried goods back and forth. Even today, some of the antique paths paved with stone slabs are still trodden by teams of pack horses and mules.

To the west of the town, the ancient road creeps up a mountain slope, where Xishan Temple, built in the Jin Dynasty (265-420), is located. The god of the land was worshipped here, especially by the caravan traders. At the top of the mountain stands an arch, all that remains of Jiangding Temple. At the bottom of the further slope, the Lancang River forms the border between Dali Prefecture and Baoshan City.

The Changchun Taoist Temple is octagonal in shape, and houses exquisite frescos and wood carvings.

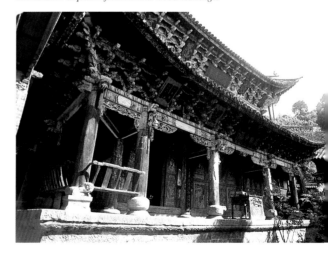

Yunlong Bridge in Yangbi County is a mountain pass on the ancient Bonan Road. In the 12th year (1639) of the Chongzhen reign period of the Ming Dynasty, Xu Xiake, a famous traveler, visited this bridge.

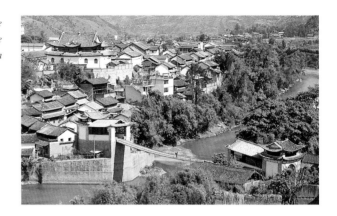

Frescos on the ceiling of the grand hall of Changchun Temple.

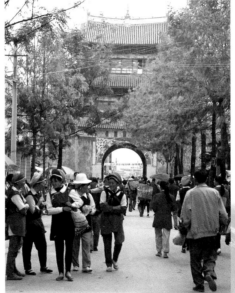

Situated in the center of Heqing County, Yunque Tower was built in the ninth year (1514) of the Zhongde reign period of the Ming Dynasty. It is commonly called the Bell and Drum Tower.

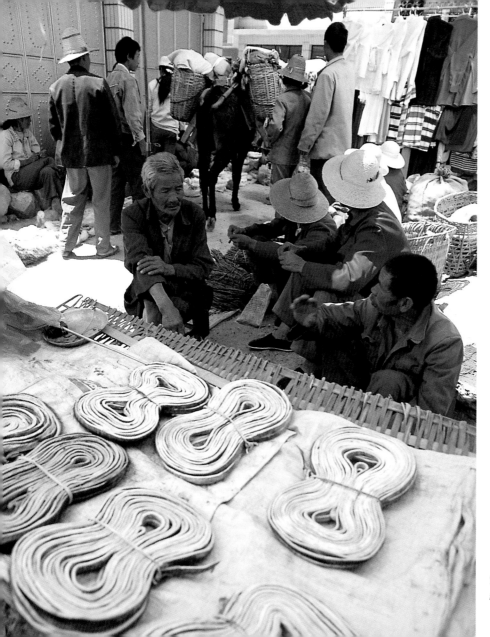

The ancient town of Shanyang used
to be famous for its caravans .

Ancient Way Across the Lancang and Nujiang Rivers, and Gaoligong Mountains

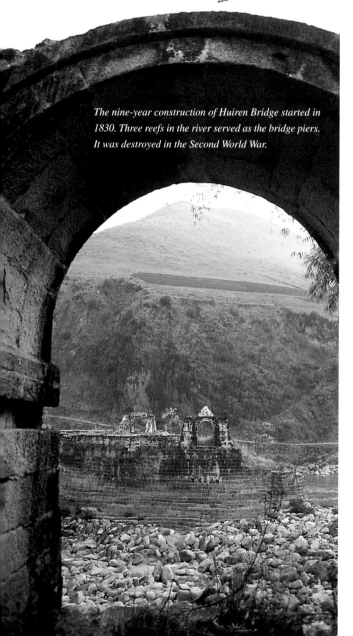

The nine-year construction of Huiren Bridge started in 1830. Three reefs in the river served as the bridge piers. It was destroyed in the Second World War.

Ancient Way Across the Lancang and Nujiang Rivers, and Gaoligong Mountains

Lancang Ferry and Jihong Bridge

The Lancang Ferry was set up during the reign of Emperor Mingdi of the Eastern Han Dynasty. It was replaced by a rattan bridge, and in 1475 a chain bridge 106 m in length and 4 m in width was constructed, with 18 iron chains. As it looked like a rainbow high in the air, it was named Jihong (rainbow) Bridge and was the oldest chain bridge in China. The bridge was washed away in 1986, together with a depository of rare books located on the east bank of the river. On the cliffs of the west bank, there can still be seen inscriptions carved by men of letters through the ages, expressing awe and admiration of the bridge and its precipitous location.

Yongchang City, Echoes of the Kingdom of Ailao

Crossing the Lancang River, the Silk Road reaches Baoshan, which was the capital of the Kingdom of Ailao in antiquity. According to legend, the founder and first king of Ailao was the son of a river dragon and a local woman. Ailao stretched from the Lancang

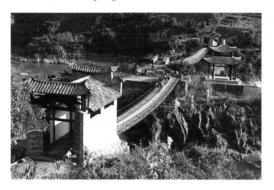

Initially built in 1789, Shuanghong Bridge is 162.5 m long and was the first chain bridge built over the 1,000-li Nujiang River.

River in the east to the borders of India and Myanmar in the west; and from Tibet in the north to Xishuangbanna in the south.

In the Han Dynasty, Baoshan was the center of Yongchang Prefecture. Merchants at home and abroad, especially India and Myanmar, gathered in Yongchang to trade in rare birds and animals, gold, gems, jadeite, silkworms, colored glaze, silk cloth, ivory, peacocks and elephants. Yongchang was among the first regions in China to make cotton cloth, and the local Tonghua cloth and Langan muslin were very popular.

On the western edge of Baoshan lies the grand canyon of the Nujiang River, which rises at the southern foot of Mt Tanggula on the Qinghai-Tibet Plateau. The roaring current gives it its name (*nu* means angry in Chinese). All along the Nujiang River, the topography is difficult, but the Baoshan sector of the Silk Road is a fertile flatland in the river valley, where tropical and subtropical plants such as bananas, coffee, litchis, mangoes, longans and sugarcane grow. Called a "natural greenhouse," the river valley has a high temperature all the year round, and rice can be grown there in any season.

On Yongchang Road, there are three ancient chain bridges over the Nujiang River: Huitong Bridge, Huiren Bridge and Shuanghong Bridge. Only the last one survived the Second World War. The Gaoligong Mountains stand guard before the river, rising some 3,000 m above sea level and extending several hundred *li* (one *li* equals to half a kilometer) from north to south, forming a natural fortress. The ancient road here traverses precipices and steep slopes, and it took at least three days for caravans to complete this stretch of the journey. On the mountain are scattered relics of ancient roads, passes and beacon towers. In the 1940s, the Chinese army fought a desperate but ultimately victorious battle against the Japanese invaders here.

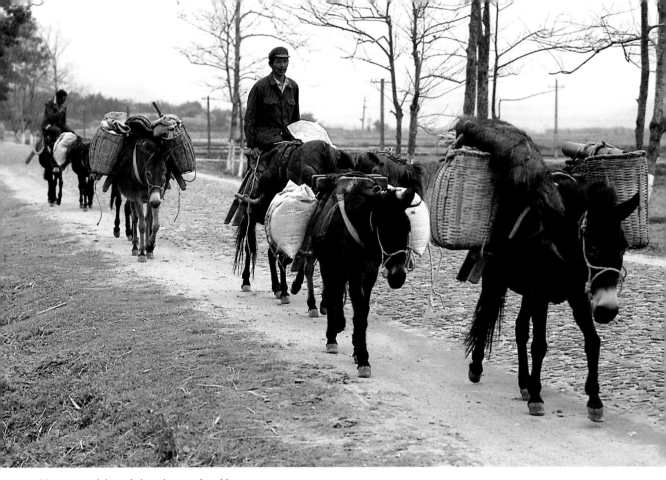

Many stone slab roads have been replaced by asphalt highways, and pack horses are seldom seen nowadays.

Yuhuang Temple, a leading Taoist temple, was established in 1545. Huizhen Tower, north of the grand hall, was where Xu Xiake stayed when this great traveler visited Baoshan.

Around Tengchong there are over 40 volcanoes. They have been dormant for 380 years.

Trenches dating from the battle can still be seen.

Tengchong's Volcanoes and Hot Springs

On the other side of the Gaoligong Mountains lies the city of Tengchong, famous for its 100 or so hot springs and one of only three spa towns in China. The most noted thermal springs are at Hot Sea, 20 km from the county town, where the water temperature is 97 degrees centigrade.

With a 148 km border with Myanmar, Tengchong became an important frontier town and thoroughfare to Myanmar at a very early date, and was a leading

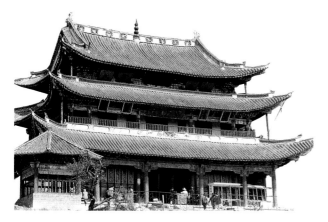

commercial city in the region. During the Ming and Qing dynasties, caravans from Myanmar, India and the hinterland of China constantly came and went through Tengchong. In the late Ming and early Qing dynasties, many people migrated abroad from Tengchong. In modern times, it was through Tengchong that many European industrial products entered China from Myanmar. In the Second World War, Tengchong was almost leveled to the ground. Nowadays, it is famous for jade processing, with the materials coming from Myanmar. In the early part of the 20th century, there were already 500-odd jade workshops, and over 3,000 craftsmen here.

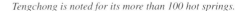
Tengchong is noted for its more than 100 hot springs.

Heshun, a Village Inhabited by Relatives of Overseas Chinese and Returned Overseas Chinese

Four km southeast of Tengchong, there is a village surrounded by large and small volcanoes, known as Heshun. There are 1,300-odd families with 6,300 people in the village, and over 5,000 people with roots in Heshun live abroad. The Sanhe River flows around the village, the paths of which are paved with stone slabs. Near the village gates are semi-circular platforms with stone rails and stone chairs. In the center of these platforms are big banyan trees. Here, the villagers sit and chat, enjoying their leisure, or gather for public discussions. Beside each public washing pond there stands a pavilion. Near the entrance to the village, there is the Heshun Library, which combines Chinese and Western architectural styles. Built in 1929, the library now has a collection of over 70, 000 books, including many rare and precious ones.

Guoshang Martyrs' Cemetery. On May 10th, 1944, six divisions of the Chinese expeditionary army forced their way across the Nujiang River and launched a general offensive against the Japanese invaders who had occupied Tengchong for two years. After 40-odd battles, the Chinese army won the final victory, with a loss of its 9,168 soldiers. This whole hill is covered with the tombs of 3,346 martyrs.

Mountain of Swords and Sea of Flames of the Lisu Nationality

One route of the ancient Silk Road winds out of Tengchong into Myanmar by way of today's Dehong Prefecture; the other route goes to Myanmar via the Guyong Pass in Tengchong. The Stilwell Highway, constructed during the Second World War, follows the route of the ancient Southwestern Silk Road by and large. It begins at Baoshan, and eventually leads to India. After being cut for 40 years, this road was repaired and re-opened to traffic in 1993. By the Binglang River, there is a ruined fortress six m high. It is said that in the past it was garrisoned by warriors of the Lisu nationality armed with crossbows which shot poisoned arrows.

The seventh day of the second month by the lunar calendar is the Sword Pole Festival of the Lisu people of Guyong Village. At night, a bonfire is lit, and when the flames die down, some of the Lisu men jump into this "sea of flames" bare-footed, and perform

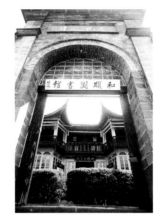

Heshun Library

somersaults. On the next day, two tall wooden poles are erected in the same place, with 72 sharp swords bound to them, their blades pointing upward. Some Lisu men in majestic costumes, after performing devout sacrificial rites to the gods, climb to the tops of the poles, placing their bare feet on the sword blades. These activities are held in memory of Wang Ji, a Ming general who came here to fight marauders.

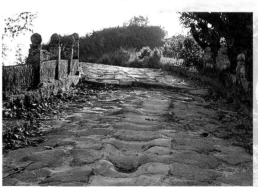

An ancient road, ancient bridge and deep ruts

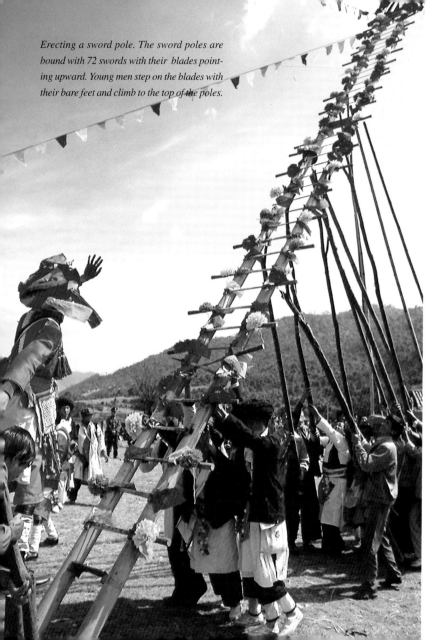

Erecting a sword pole. The sword poles are bound with 72 swords with their blades pointing upward. Young men step on the blades with their bare feet and climb to the top of the poles.

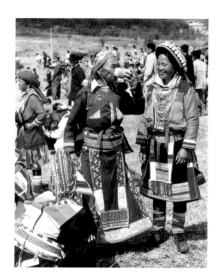

Many Lisu people in Guyong Village are descendants of soldiers who garrisoned the nearby border area. The local women's clothes, according to legend, were made by sewing military flags together.

The Victorious Fortress, built in the Qing Dynasty, has long fallen into ruins, but still keeps its majestic appearance.

Dehong, Home of Peacocks

Dehong, Home of Peacocks

By way of Tengchong, Yongchang Road enters the Dehong Autonomous Prefecture of the Dai and Jingpo nationalities. With an area of 11,173 sq km and a population of 900,000 people, Dehong Prefecture has four counties and two cities under its jurisdiction, namely, Luxi, Lianghe, Yingjiang, Longchuan, Ruili and Wanding. The ancient Southwestern Silk Road passes from Tengchong to Lianghe, then forks, with one route leading to Myanmar from Zhangfeng, and the other to Yingjiang. Dehong's low latitude, subtropical climate and plentiful rainfall have given it a beautiful natural landscape, with huge banyan trees, limpid rivers, flowers blooming all the year round, tropical fruits and sugarcane fields. In addition, the charming scenes are complemented by stilt houses of the Dai nationality, and Buddhist structures . As the Dai people believe in Hinayana Buddhism, Buddhist temples and pagodas can be seen everywhere. In 1950s, there were about 500 temples in the area of Dehong. Hinayana Buddhism practiced in this area formerly came from Myanmar through the Southwestern Silk Road.

Built in the first year of the reign of Emperor Xianfeng of the Qing Dynasty, the government office of national minority hereditary headmen of Nandian in Lianghe covers 9,380 sq m. Four generations of hereditary headmen ruled this area from here for 94 years.

Ancient Battlefield of Elephants and Horses

In 1275, Marco Polo, the Italian traveler who served at the court of the Yuan Dynasty for 17 years visited Dehong on expedition to Myanmar with the Yuan army. In his *Travels of Marco Polo,* he recorded a battle in which the army from Myanmar used elephants. The Yuan army's horses panicked at their first sight of these huge beasts, but the Yuan troops finally won the battle by using arrows to kill those elephants. According to experts, this battle took place by the Daying River near today's Lianghe County town.

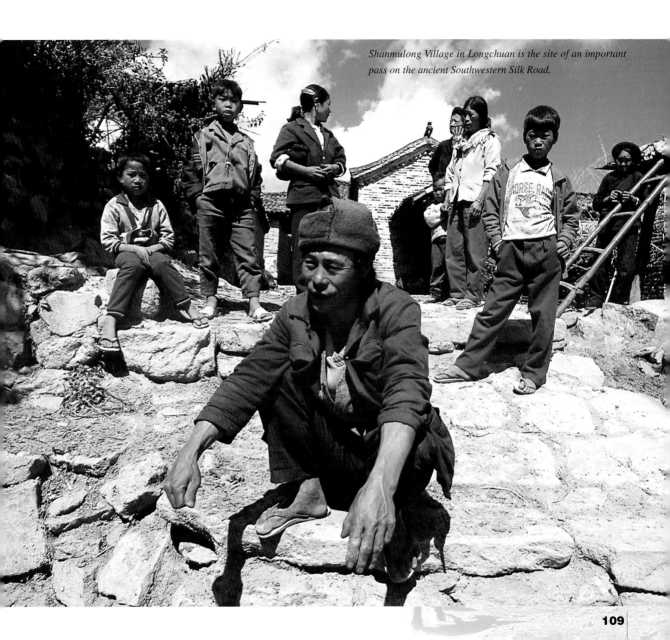

Shanmulong Village in Longchuan is the site of an important pass on the ancient Southwestern Silk Road.

Huge banyan trees are common in southwestern Yunnan.

In the Lianghe County town, there is a group of ancient buildings – the government offices of the national minority hereditary headmen, which was built in the first year of the reign (1851) of Emperor Xianfeng of the Qing Dynasty. The system of governing ethnic regions by appointing local headmen was instituted under the Yuan Dynasty. The headmen passed their authority down from generation to generation. During the Ming and Qing dynasties, the central court successively established 10 ethnic regions governed by hereditary headmen. It wasc not until the founding of New China in 1949 that this system was thoroughly abrogated.

In Mangshi there is a tree which has taken root on the top of a 200-year-old tower.

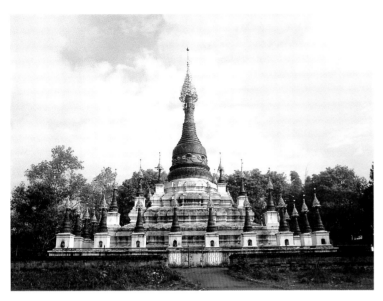

The Manding Buddhist pagoda in Yingjiang was built during the Republic of China (1911-1949), and rebuilt in 1956.

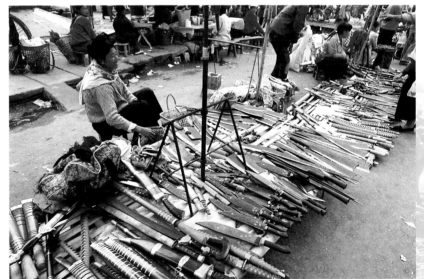

"Husa Swords" made by the Achang people of Husa Village in Longchuan is a local product well known all over the country.

Gallery of National Conditions and Customs

Dehong Prefecture is home to people of the Dai, Jingpo, Achang, De'ang, Lisu, Wa and other ethnic groups. The 110,000 Jingpo people living in the prefecture have their homes high in the mountains of 1,800-2,000 m above sea level. The Achang people of Longchuan are noted for their skill at metal working. According to legend, they learned how to make swords from Zhuge Liang when

this military genius went on expedition to the south. It is interesting to note that many legends and stories about Zhuge Liang circulate in Dehong, although in fact he never visited the area. The De'ang ethnic group numbers only about 10,000

people, who mainly live on Mt Santai. The De'ang women like to chew areca nuts, and regard black teeth as a criterion of beauty. In Dehong Prefecture, the Dai nationality has the largest population, nearly 300,000 people. The Dai people live in bamboo houses built on stilts and surrounded by bamboo groves and banyan trees.

De'ang women in their traditional costume

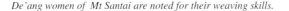
De'ang women of Mt Santai are noted for their weaving skills.

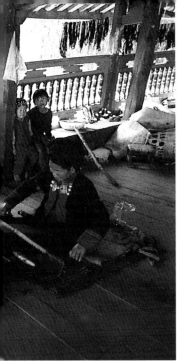

Deang women like to chew areca nuts, which blacken their teeth.

Yunnan-Myanmar Highway

It was not until in the late 1930s that the Southwestern Silk Road in the Dehong area entered the age of the highway and the automobile. In the war against the Japanese invaders in 1937, soldiers and civilians in Yunnan joined hands to construct part of the Yunnan-Myanmar Highway, roughly following the route of the ancient Silk Road. This section starts at Dali and ends at Wanding. After only nine months, the 524.6 km stretch of the highway was completed. At that time, journalist Xiao Qian wrote, "There will come a time when our descendants will stand at the foot of Mt Gaoligong, and ask: 'How was this possible?' In building a 973 km highway for automobiles (including the part from Kunming to Xiaguan, 434 km long and built in 1935), setting up 370 bridges, completing a paving project of 1,400,000 cubic *chi* (a traditional Chinese unit of length) and moving nearly 20,000,000 cu m of earth, the constructors did not

The Dai people are fervent Buddhists.

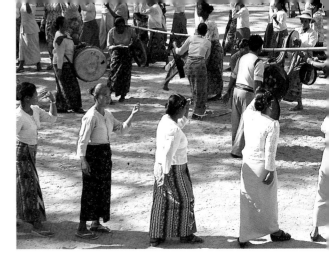

use a single machine, nor did they use large amounts of money. But with the concerted efforts of 25 million workers they built the road with earth, stones, and their flesh and blood..." This Yunnan-Myanmar Highway, constructed with flesh and blood, became the only land passage open to foreign transportation and international support for China in wartime, and made a great contribution to the ultimate defeat of the Japanese invaders.

Exit of the Silk Road, Ports on the Border

Dehong Prefecture has a 503.8 km border with Myanmar. Many mountain ranges in Dehong extend into Myanmar, and all the rivers in Dehong flow into the Irrawaddy River in Myanmar. Three counties and two cities in Dehong adjoin five Burmese cities, namely, Namhkam, Motai and Jiugu counties, and the cities of Nashu and Bhamo. Along the boundary are located over 600 villages, many of which are not far from their counterparts in Myanmar, and some are even partly in China and partly in Myanmar. Dehong has been the gateway of southwest China since ancient times. Trading and intermarrying with each other, the people living peacefully in the border areas of the two countries have enjoyed a traditional and profound friendship from time immemorial. In the Qing Dynasty, Zhangfeng, Yingjiang and Ruili were all thriving trading ports. In the 1930s and 1940s, with the completion of the Yunnan-Myanmar Highway, Wanding became a major international crossing point once again. Now in Dehong there are two border crossings — Ruili and Wanding—at state level, and others such as Yingjiang, Zhangfeng and Mangshi at provincial level.

At the markets along the border, merchants from Myanmar, Thailand, India and Pakistan, and their counterparts of the Dai, Jingpo and Han ethnic groups from China set up stalls and do business.

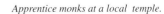
Apprentice monks at a local temple.

The Munao traditional singing festival is the highlight in the Jingpo people's life.

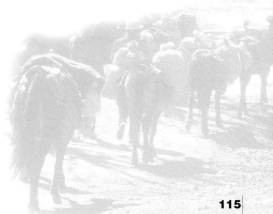

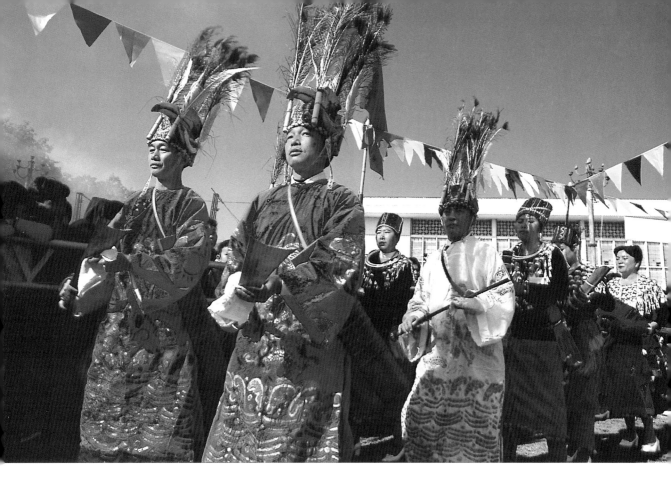

Naoshuang (leading dancer) wearing peacock features
walks in the forefront of the dancing team.

Wanding Bridge is where the Yunnan-Myanmar Highway crosses the
border. During the Second World War, over 100,000 Chinese troops
crossed this bridge in their advance against the Japanese invaders.

The site of Tongbi Pass is located in Yingjiang County. The pass used to be one of the eight border passes operating during the Ming Dynasty.

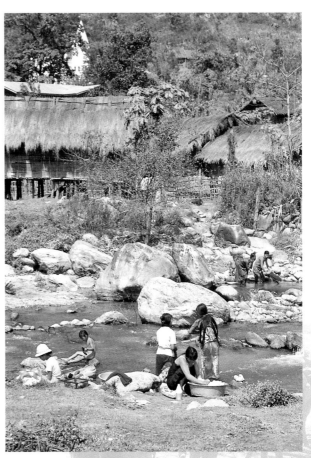

The Ruili River flows from China into Myanmar.

Many Chinese villages in Yunnan are separated from villages in Myanmar only by a river.

Epilogue

The Silk Road in northern China was mainly formed by the treading of millions of feet, while that in southwestern China was mainly opened up by overcoming obstacles. As early as in the Qin Dynasty, plank roadways and bridges were constructed to penetrate the precipitous mountains and deep gorges. In the Sichuan Basin, the climate is rainy and humid, and the roads are always muddy. So, generations of people labored to pave the road with stone slabs. These slabs can still be seen today, winding across mountains and through dense forests.

The Silk Road in north China was a "national road," along which diplomatic envoys traveled on their way to present tribute to the emperor, and caravans carried large amounts of goods in both directions, keeping open a trade lifeline between China and the West. The goods were both valuable and exotic—silk, magnificent horses, lions, colored glaze, agate and carpets... As for the Silk Road in the southwest, it declined with the rise of the Silk Road in the north and the maritime Silk Road. From then on, the goods circulated by this road were mainly food and daily necessities, such as silk, tea, horses and salt. In mod-

ern times, this road flourished for a time once again, due to its strategic role in defeating the Japanese invaders during the worldwide War Against Fascism.

More than 2,000 years ago, the Silk Road in southwest China linked two great civilizations—those of China and India, and connected Asia with Europe and even Africa. Because of the complicated landforms along its route, the long and rugged ancient road stagnated as the centuries passed. However, the ancient Southwestern Silk Road has bequeathed to posterity great numbers of historical relics of Sino-foreign exchanges and traits of cultural assimilation, which makes the ancient road a worthy subject of research by today's scholars and scientists. Along the road there are endless enigmas to unravel and numerous cultural phenomena, the origin of which still needs to be traced.

The Southwestern Silk Road, now serene, winds on ahead of us.

The ancient Tiansheng Bridge in Jiyi County, in the Wuding area, is still in use today.

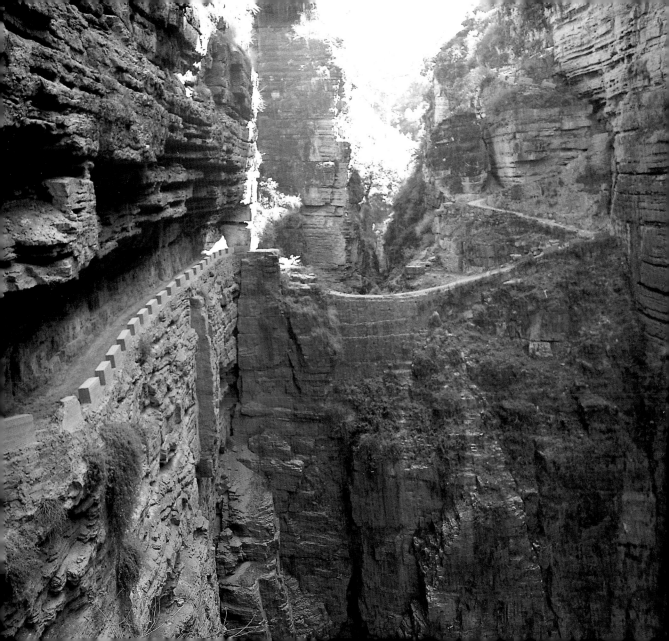

图书在版编目（CIP）数据

中国西南丝绸之路／鲁忠民编著.－北京：外文出版社，
2002.7
（中华风物）
ISBN 7-119-03052-3

Ⅰ．中…Ⅱ.鲁… Ⅲ.中国西南丝绸之路－简介－西南地区
－画册　Ⅳ.k928.6－64
中国版本图书馆 CIP 数据核字(2002)第 023418 号

《中华风物》编辑委员会

顾问：蔡名照　赵常谦　黄友义　刘质彬
主编：肖晓明
编委：肖晓明　李振国　田　辉　呼宝珉　房永明　胡开敏
　　　崔黎丽　兰佩瑾

图　　文：鲁忠民

责任编辑：王　志
翻　译：郁　苓 顾文同 陈平
设　计：王　志

中国西南丝绸之路

ⓒ 外文出版社
外文出版社出版
（中国北京百万庄大街 24 号）
邮政编码：100037
外文出版社网页：http://www.flp.com.cn
外文出版社电子邮件地址：info@flp.com.cn
　　　　　　　　　　　sales@flp.com.cn
天时印刷(深圳)有限公司印刷
中国国际图书贸易总公司发行
（中国北京车公庄西路 35 号）
北京邮政信箱第 399 号　邮政编码 100044
2002 年(24 开)第 1 版
2002 年第 1 版第 1 次印刷
（英文）
ISBN 7-119-03052-3/ J ·1587（外）
05800（精）
85-E-532S